Charles Sumner, page 37

BOSTON STATUES

BOSTON STATUES

Walter Muir Whitehill

WITH
PHOTOGRAPHS BY

Katharine Knowles

BARRE PUBLISHERS * BARRE, MASSACHUSETTS * 1970

Copyright © 1970 by Barre Publishers, Inc.
Library of Congress Catalog Card Number 72-128387
Standard Book Number 8271-7015-7
Designed by Klaus Gemming
Printed in the United States of America
All rights reserved

INTRODUCTION

When Lord Bryce described Buenos Aires as it was early in this century in his *South America, Observations and Impressions*, he spoke approvingly of the numerous small plazas throughout the city, but added that "the statues which adorn these plazas do not tempt the passer-by to linger in aesthetic enjoyment." He continued: "One is too acutely reminded of the bronze equestrian warriors so numerous in Washington. The cities of the western world, having a short history, seem to run to the commemoration of heroes whose names, little known to other countries, will soon be forgotten in their own." There is, indeed, an extraordinary profusion of statues in Washington, for the L'Enfant plan of the city, with its avenues radiating from squares and circles, provided a great number of tempting sites. In succumbing to this temptation, citizens of the Americas, both North and South, were simply carrying out European tradition to the best of their resources.

For a light-hearted and irreverent view of what has gone on in London, one has only to turn to *The People's Album of London Statues*, published in 1928 by Osbert Sitwell, with drawings by Nina Hamnett. Sir Osbert begins by wishing that his countrymen had shown more respect for the Second Commandment, continues with essays on statues in general, on statues in London, and, looking to the future, suggests that some of the surplus examples be forced to emigrate. Although the time has passed when they could be sent to America, there is still a great deal of space in Upper Canada, Australia, and New Zealand where "these frock-coated and whiskered effigies would find a more free and open life than huddled together in the Old Country," where they would "take on a still more incongruous dignity." It is not that they are all frock-coated and bewhiskered; the unfortunate clean-shaven Conservative politician William

Huskisson, who was wearing a top hat when run over and killed by a primitive railway train in 1830, stands on a pedestal in Pimlico Gardens, simply draped in a large towel, a "classic figure of Boredom rising from the bath."

Osbert Lancaster constantly makes fun of statues in his enchanting architectural drawings and cartoons. On the dust-jacket of his *Façades and Faces* (1950), the Countess of Littlehampton, weary of sightseeing, is seated on the base of a column in the courtyard of a baroque palace. She has slipped off her shoes and rubs a tired foot as she looks enviously at the colossal statue of Hercules, who is carrying away in his powerful arms a relaxed naked lady. The illustrations to Lancaster's "Afternoons with Baedeker," which open the volume, are full of statues in public squares: a sword-waving Italian general on a rearing horse, a sombre statesman-in-toga in a Dublin square, a bewigged Bavarian prince in Roman armor, also on a rearing horse, a French lady clad only in a Liberty cap, waving a palm in her right hand and supporting with her left the corpse of a *poilu mort pour la Patrie*.

George Molnar in 1955 published in New York a volume of cartoons, simply entitled *Statues*, containing all kinds of inspired suggestions for the enlargement and improvement of statues, including a foresighted reversible one to celebrate the Victor of a South American Civil War. This design has a general with upraised sword and a workman with upraised hammer, placed at a ninety degree angle to one another. Set in one position, the triumphant general threatens the worker who lies on his back. In the event of the war turning out the other way, the relation of the figures can be transposed, by the simple use of a block and tackle. Then too there are Denison Hatch's engaging volumes, *Statuary Rape, A Libelous Look at Life Among the Marbles* (1959) and *Statues of Limitations, Intimate Views of Life Among the Marbles* (1961) where inspired captions are attached to well-known sculptures of all eras. The wounded Niobid in the Terme Museum in Rome, whose arms are both behind her and whose garments only cover her right leg, is calling to someone named Harry to zip her up, while Remus, sucking at one of the udders of the Capitoline

6

wolf, informs brother Romulus with delight that this one is chocolate.

Lord Bryce's remark set me to thinking about the Boston statues which I have passed all my life, which are neither as numerous nor as ridiculous as those in some cities. The only descriptions of many of them are in two pamphlets published by the State Street Trust Company in the series instigated by its late president, Allan Forbes (1874–1955). *Some Statues of Boston* (1946) and *Other Statues of Boston* (1947) with text by Allan Forbes and Ralph M. Eastman, provide a fair pictorial record, but as they are arranged alphabetically by subject, they give no indication of chronology and little suggestion of the municipal state of mind that caused the statues to be erected. I tried to fill some of these gaps in a paper read at a meeting of the American Historical Association in Ottawa on 28 December 1967, which is now expanded into a little book, illustrated with photographs by my North Andover neighbor, Miss Katharine Knowles. Most of the statues described here have stood on their pedestals as long as I can remember. Now and then a new one appears, or an old one is trundled off to a new location because of building or highway construction. They have gained title to the space that they occupy through act of the Legislature, or by approval of the Boston Art Commission, but neither body seems to have shown great devotion to any abstract principle of selection. If a subject, ancient or modern, inspired enough votes for a public appropriation, or enough popular enthusiasm to cause a single donor or a public subscription committee to provide the funds for a statue, and the statue proved not to be in grotesque violation of the artistic taste of the time, up it went.

Our earliest approach to a national pantheon sprang from a resolution of Representative Justin Smith Morrill of Vermont, which led (by proviso of a bill of 2 July 1864) to setting apart the old Hall of Representatives in the Capitol in Washington as a national Statuary Hall. With the completion of the wings of the Capitol in 1857, the Supreme Court moved into the old Senate chamber, but the old House languished, "draped in cobwebs and carpeted with dust," as Morrill described it seven years later. Hawkers and hucksters moved in, as is apt to occur in a vacant space in the United

States where potential buyers pass in any number. In supporting Morrill's resolution, a representative observed: "I look to see where . . . Clay sat and I find a woman selling oranges and root beer." So in July 1864 the bill passed. The hucksters were swept out, and the President was authorized to invite each state to contribute two statues of outstanding deceased citizens.

Statues began to arrive in the hall in 1870. Massachusetts sent marble likenesses of Governor John Winthrop and of Samuel Adams, both of which were subsequently reproduced in bronze for sites in Boston, as will be seen later in this volume. Apart from this enthronement of Winthrop and Sam Adams in the Capitol pantheon, what did Boston do about statues in the nineteenth century, and who was commemorated? For the first half of the century, the answer is almost nothing, for there were no local sculptors capable of heroic statuary in bronze or marble. An eighteenth century Bostonian with an itch for memorialization was obliged to send to London, and the most that any of them aspired to was a memorial tablet, with no more than a bust by way of portrait. Three characteristic examples of this type of commemoration are still to be seen on the walls of King's Chapel, an enchanting building that still preserves the flavor of Tory-Anglican, pre-Revolutionary Boston.

Present-day fund-raisers delight in suggesting how donors may immortalize themselves by providing funds for memorial broom closets, electrical control panels, and the like, even if their gifts are too modest to pay for a more conspicuous part of a building. It seems not unlikely that the three memorial tablets imported from England were allotted space in King's Chapel because their donors had contributed to the construction of the present building. The Church of England first came to Puritan Boston in 1686, when royal authority was definitely established there with the sending of Sir Edmund Andros as the first royal governor of the Province of Massachusetts Bay. Anglican services were initially held in the Town House; then, to the disgust of its rightful congregation, in the Old South Church. Finally in 1689 a modest wooden King's Chapel, built in one corner of the old burying ground at Tremont and School Streets, was opened for Anglican worship. Although enlarged in 1710, this building

was by 1741 so inadequate and in such poor repair that it was proposed that it be rebuilt of stone. To this end a subscription paper was circulated, on which two of the more generous pledges were made by sometime wardens of the church, William Shirley (1693–1771), Governor of the Province of Massachusetts Bay, 1741–1756, and Charles Apthorp (1698–1758), a merchant who had greatly prospered through army contracting. Although the first subscription languished, a second was undertaken in 1747, with Apthorp as treasurer. Again both he and Governor Shirley made generous pledges.

In the course of 1749 Peter Harrison completed the plans for the present stone building; construction was begun in 1750, although it was 21 August 1754 before it was first used for service. On the wall of the south aisle, beside the royal governor's canopied box pew, William Shirley promptly placed a monument in memory of his first wife, Frances Barker, who had died in 1746, and of their daughter Frances, the wife of William Bollan, who had died in 1744. This took the form of a tablet, with an immensely long Latin inscription setting forth the virtues of both ladies, surmounted by a charming bust of one of them. As befitted such a memorial offered by a man of Shirley's position, it was by the London sculptor, Peter Scheemakers (1691–1781), who had in 1740 carved the monument to Shakespeare in Westminster Abbey. The artist was a native of Antwerp, the son of a sculptor, who had walked to Copenhagen and then to Rome for study before settling in London about 1716. There he remained, busily at work, until 1771, when, as an old man, he returned to Antwerp. Of the sixty-nine monuments by Peter Scheemakers listed by Rupert Gunnis in his *Dictionary of British Sculptors, 1660–1851*, fourteen are in Westminster Abbey, while busts that Scheemakers did of Milton, Spenser, Shakespeare, and Dryden were presented by Frederick, Prince of Wales, to Alexander Pope. The Shirley monument is, according to Rupert Gunnis's list, the only work by Scheemakers in British North America.

William Shirley, by then a widower, had been absent from Boston on leave from 1749 to 1753. While in England he had been appointed a member of a commission sitting in Paris to determine the boundary

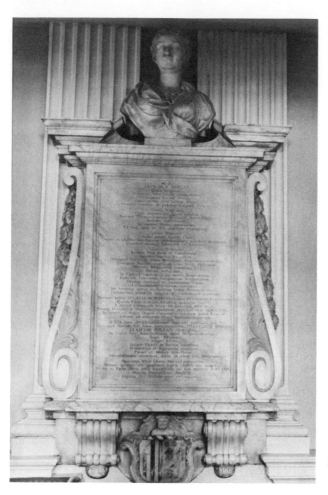

Shirley monument
by Peter Scheemakers in King's Chapel

between French North America and New England. During his extended
duties in Paris, he had committed the political solecism of marrying Julie,
a young Frenchwoman, who was his landlord's daughter. This created
such unfavorable comment in London and Boston that he left Julie in Paris
when he returned to New England in 1753. Possibly this event was not
unrelated to his erecting in the new King's Chapel the fulsome tablet by
Scheemakers, which sets forth at such length, immediately beside the
governor's pew, the dignities and virtues of the lady who had earlier shared
the Province House with him.

When Charles Apthorp died in 1758, he was elegantly commemorated
in the north aisle of King's Chapel with a tablet executed by Henry Cheere

(1703–1781) of London. Here too there is a sonorous Latin inscription, characterizing the deceased as

PATERFAMILIAS PRUDENS ET LIBERALIS,
MERCATOR INTEGERRIMUS,
INSIGNI PROBITATE CIVIS,
INTER HUIUS AEDIS INSTAURATORES
PRAECIPUE MUNIFICUS,
SINCERA FIDE ET LARGA CARITATE
CHRISTIANUS,

surmounted, not by a portrait bust, but by a plump cherub, weeping beside an urn. As Apthorp's wife and five-sixths of their eighteen children had survived him, the inscription concludes grandiloquently:

Charles Apthorp monument by Sir Henry Cheere in King's Chapel

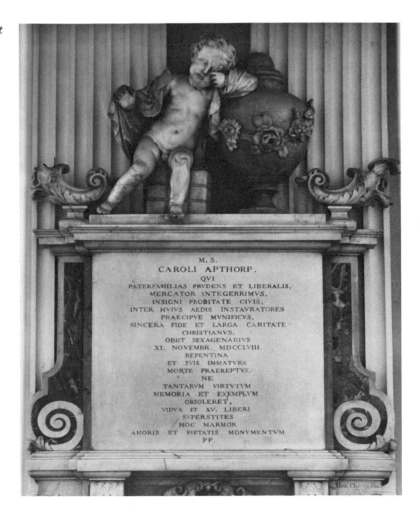

NE
TANTARUM VIRTUTUM
MEMORIA ET EXEMPLUM
OBSOLERET,
VIDUA ET XV LIBERI
SUPERSTITES
HOC MARMOR
AMORIS ET PIETATIS MONUMENTUM
PP.

Like Governor Shirley, the Apthorps had recourse to a stylish London craftsman, for Henry Cheere had in 1733 executed the statue of Queen Caroline for Queen's College, Oxford, and in 1734 one of William III for the Bank of England. Of the twenty-nine monuments attributed to him by Rupert Gunnis, nine are in Westminster Abbey. The Apthorp memorial, his only work in British North America, was also his last of this type, for honors crowded in upon him. In 1760 he was knighted, when he presented a congratulatory address to George III from the County of Middlesex; in 1766 he was created a baronet, and in 1770 he gave up his yard near Hyde Park Corner and retired from business.

The third eighteenth century London sculptor to be represented in King's Chapel is William Tyler, R.A. (died 1801), who executed in 1766 the monument to Samuel Vassall (1586–1667) that stands on the west wall, to the left of the principal entrance to the church. The presence in Boston of a posthumous bust of a seventeenth century member of Parliament, who never set foot in New England, is an indirect consequence of the fund-raising of the 1740s. In 1748, when local contributions dragged, appeals were broadcast to potential benefactors in England and friendly colonies. Among these was one sent to William Vassall in Jamaica, accompanied by a subscription form addressed "To all charitable and well disposed Gentle-men in the Island of Jamaica." It did not produce any remarkable results, although Florentius Vassall, whose life was spent between Jamaica and England, did subscribe ten guineas. A dozen years after the church was in use, however, Florentius shipped to it this monument to his great-grand-

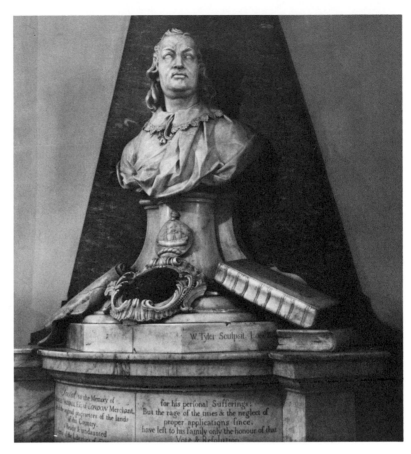

Samuel Vassall monument by William Tyler in King's Chapel

father, with the request that it be erected in King's Chapel. The political views of the subject, who was described as "a steady and undaunted asserter of the Liberties of England," were opposite-minded enough to appeal to some Bostonians in 1766, for in 1628 "he was the first," so the inscription states, "who boldly refused to submit to the tax of Tonnage and Poundage, an unconstitutional claim of the Crown arbitrarily imposed: For which (to the ruin of his family) his goods were seized and his person imprisoned by the Star Chamber Court." But he had his innings later, for he was elected an M.P. for London in the Short and Long Parliaments of 1640, and in due course was voted by Parliament £10445/12/2 for his damages. This fact was recorded, down to the pennies, in the lengthy inscription

that William Tyler carved on the monument. It was so large that it could only be installed by removing pew 43, on the north side of the west door; as Vassall's representative in Boston paid £33/6/8 for the pew, the monument was accordingly put in its present location, where it has puzzled many church-goers and visitors ever since.

Had the American Revolution not intervened, more London-made memorials might have come to Boston to join the Scheemakers, Cheere, and Tyler works in King's Chapel. As it was, the next significant memorial was a home-grown product, the bust of George Washington that was given in 1815 to Christ Church, Salem Street, by its senior warden, Shubael Bell. During Washington's progress through New England in 1789 he sat for two hours in Portsmouth, New Hampshire, on 3 November to Christian Gullager (or Gülager), a Danish artist, who came to America about 1781, and lived in Boston, New York, and Philadelphia until his death in the latter

George Washington monument by Christian Gullager in Christ Church

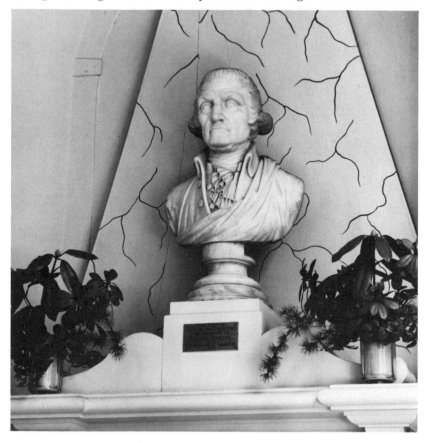

city in 1827. The not very flattering oil portrait that Gullager produced now belongs to the Massachusetts Historical Society. The Reverend William Bentley of Salem noted in his invaluable diary on 5 April 1790 that "Mr. Gullager of Boston has compleated a bust of General Washington in Plaster of Paris, as large as life," which was the prototype of the bust in Christ Church. The church has placed nearby an inscription reading: "General Lafayette, standing here in 1824 and looking at the bust of Washington, said, 'Yes, that is the man I knew and more like him than any other portrait.'" One hates to think that the anecdote is true, or that Lafayette was right. Shubael Bell's gift by no means satisfied the Boston desire to memorialize Washington, for a decade later a local committee sought to erect a full-length statue. For this purpose they had, as will shortly be seen, to turn to the British sculptor, Sir Francis Chantrey, whose work is the first to be illustrated in this series of Boston statues.

It was only in the second half of the nineteenth century, when New England-born sculptors had multiplied, that statues began to proliferate in the streets of Boston, as will be seen in the pages that follow. Of the fifty that are illustrated, only four have been erected in the second half of this century, and all of those in the 1950s. In the past decade when there has been space to fill, it has been by an abstraction rather than a portrait of anybody. Unless the wind changes in the world of sculpture, it may be some time before we have any more worthies to add to those described here.

With the exception of the Soldiers' and Sailors' Monument on Boston Common, monuments lacking portrait statues of individuals have not been illustrated. In this category are two works of Daniel Chester French: the Francis Parkman monument in Olmsted Park near Jamaica Pond (1906) and the George Robert White Memorial (1924) in the northwest corner of the Public Garden, near Beacon and Arlington Streets. Also in the Public Garden is the Ether Memorial of 1867, a Gothic fountain, surmounted by a statue of the Good Samaritan by John Quincy Adams Ward. On Castle Island, near Fort Independence, a cenotaph commemorating the great shipbuilder Donald McKay, designed by William T. Aldrich with a medallion of McKay, was erected in 1933. In various parts of Boston

Common are tablets commemorating, among other things, the founding of the city; the Reverend William Blackstone, who was on hand when the Massachusetts Bay Company arrived in 1630; Commodore John Barry; General Lafayette; and the Oneida Football Club of Boston, the first of such bodies in the United States, which played, undefeated, against all comers from 1862 to 1865.

BOSTON STATUES

GEORGE WASHINGTON

State House

THE first significant Boston statue, completed on the fiftieth anniversary of independence in 1826, was inevitably of General George Washington. As there were no local artists about who were considered worthy of such a commission, the committee promoting the memorial turned to the British neoclassical sculptor, Sir Francis Chantrey (1781–1841), the principal successor of John Flaxman. Chantrey produced a standing figure, whose contemporary costume was dignified by the superimposition of a classical mantle. The sponsoring committee proposed that the Old State House, at Washington and State Streets, be demolished to provide a site for a building worthy to house Chantrey's Washington. As this suggestion was ill received in the city, the statue was given to the Commonwealth on 26 November 1827 and eventually found a permanent home on the north wall of Doric Hall in the present State House.

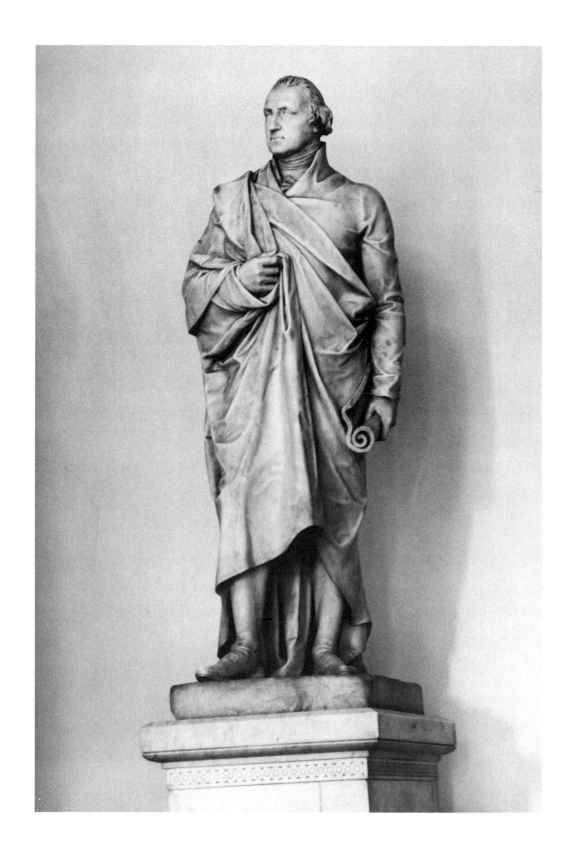

CHRISTOPHER COLUMBUS
ARISTIDES THE JUST

Louisburg Square

In 1850 modest stone statues of Columbus and Aristides the Just appeared in the fenced garden of Louisburg Square on Beacon Hill as the gift to his fellow proprietors of Joseph Iasigi, a Greek merchant, who lived at number 3. They were brought from Leghorn in one of Iasigi's ships, possibly as ballast, possibly in an unfulfilled hope of sale. These are not very remarkable works of art, nor did their subjects greatly arouse general interest. With a fountain (now disappeared), they simply contributed to the amenities of the small fenced enclosure in the center of the square. Early in this century Italian societies would visit Louisburg Square on Columbus Day with wreaths for their eminent compatriot, while Aristides, for a time, was decorated by members of an M.I.T. fraternity that once occupied the house at number 6. These are, however, garden ornaments rather than deliberate formal memorials.

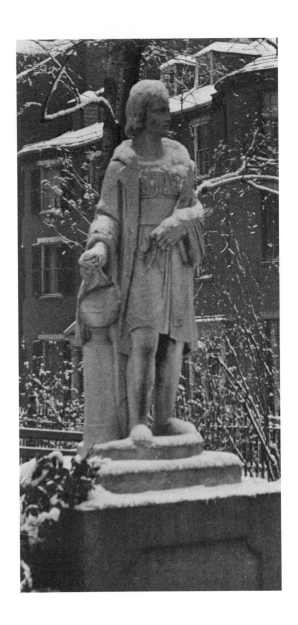

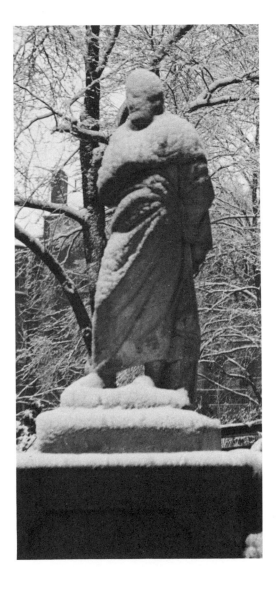

BENJAMIN FRANKLIN

Old City Hall

THE first Boston instance of canonization by statue occurred in 1856 when a bronze heroic statue of Benjamin Franklin, paid for by public subscription, was, with great pomp and ceremony, placed in front of the City Hall in School Street in honor of the sesquicentennial of his birth. It was the work of a native of Jamaica Plain, Richard Saltonstall Greenough (1819–1904), who had followed his older brother, Horatio Greenough (1805–1852), to Italy to study sculpture. Richard Greenough first gained notice in Boston through his bust of the historian William Hickling Prescott, given to the Boston Athenaeum in 1844. Local enthusiasm for his bronze group, "Shepherd Boy and Eagle," also owned by the Athenaeum, led to his receiving the commission for the Franklin statue, which stands on a square pedestal, adorned by bas-reliefs of scenes from the life of Franklin, two by Greenough and two by Thomas Ball.

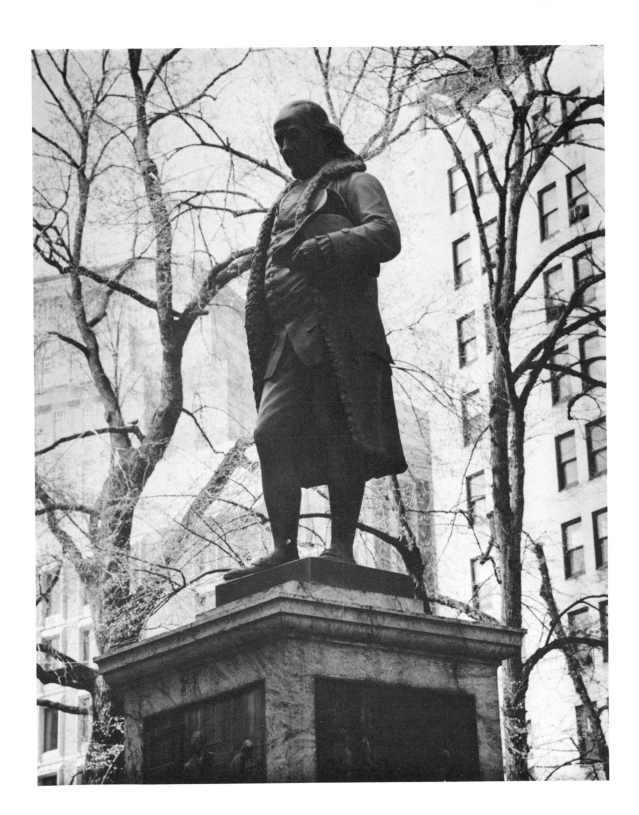

JOSIAH QUINCY

Old City Hall

Benjamin Franklin is neatly balanced by a statue of Josiah Quincy
(1772–1864), Mayor of Boston and President of Harvard College, given
by Jonathan Phillips, that was dedicated in 1879, fifteen years after its
subject's death. It was the work of another local artist, Thomas Ball (1819–
1911), the son of a Charlestown house and sign painter, who had gone to
Florence in 1854 to pursue sculpture. Much of his life thereafter was spent
in Italy. His first public commissions were the bas-reliefs of the singing
of the Declaration of Independence and of the Treaty of Paris for the
pedestal of Greenough's statue of Franklin. During a visit to the United
States for the Centennial Exposition of 1876, he was asked to submit a
design for the Quincy statue. As the family preferred his model to William
Wetmore Story's, he received the commission for this statue, which was
cast for him by Müller in Munich.

24

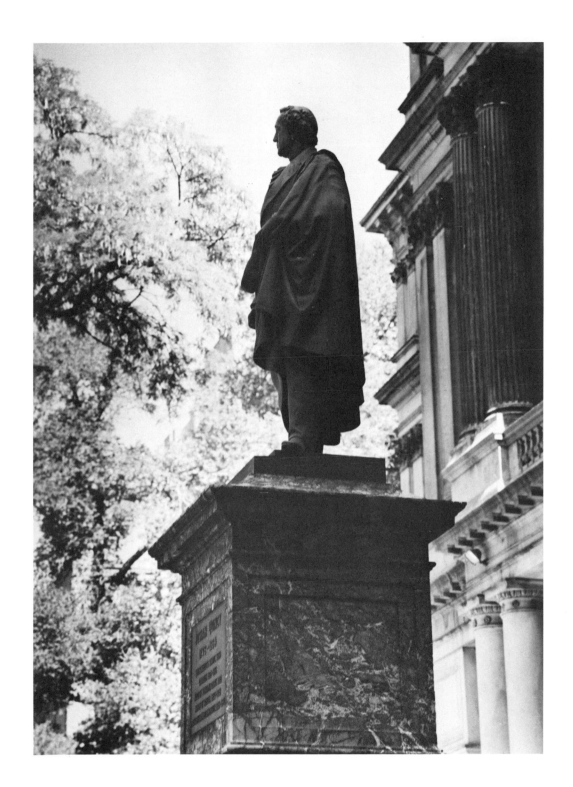

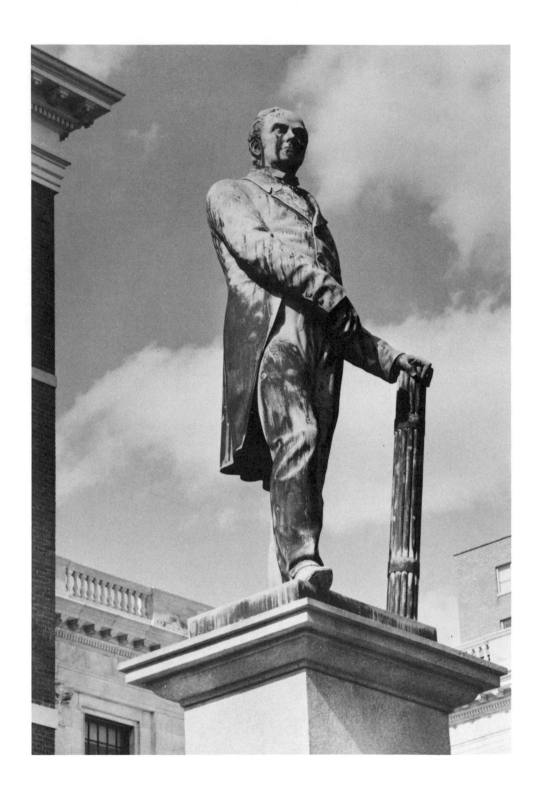

DANIEL WEBSTER

Daniel Webster (1782–1852) was canonized in bronze even more promptly than Mayor Quincy, for a Webster Memorial Committee undertook to obtain a statue of him soon after his death. The commission was awarded to the Vermont-born Hiram Powers (1805–1873), who had migrated to Florence in 1837. His first attempt, shipped from Leghorn in 1857, was lost at sea, but a second Webster statue reached Boston safely in 1859 and was placed on the terraced lawn in front of the State House. So the practice of pairing local worthies on pedestals in front of public buildings, begun at City Hall in 1856, was extended to the State House. Although Hiram Powers's statue, which depicted the subject in tail coat and trousers, without benefit of toga, had its critics, Nathaniel Hawthorne considered that "the face is very grand, very Webster."

27

HORACE MANN

WEBSTER gained a companion on 4 July 1865 when a bronze statue of Horace Mann (1796–1859) was placed opposite him on the State House lawn. Beginning as a lawyer and Massachusetts legislator, Mann became secretary of the State Board of Education upon its creation in 1837, serving until 1848, when he was elected to the seat in the United States House of Representatives vacated by the death of John Quincy Adams. From 1852 to 1859 Horace Mann was president of Antioch College at Yellow Springs, Ohio. Funds for his memorial were collected from Massachusetts school children and teachers in 1860, the year following his death; the statue was modelled in Rome by Miss Emma Stebbins (1815–1882) and cast in bronze in Munich. The sculptress veiled Mann's clothing in a voluminous mantle, producing what was not unreasonably described as "a mass of bad drapery."

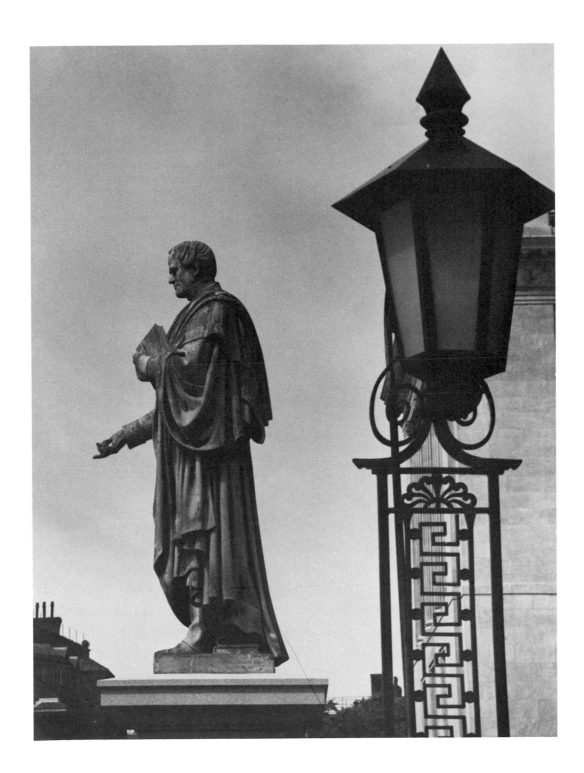

GEORGE WASHINGTON

Public Garden

IN the last third of the nineteenth century, statues of local worthies of all periods by New England sculptors began appearing in various parts of Boston. The equestrian statue of Washington by Thomas Ball in the Public Garden resulted from a meeting of the sculptor's friends in 1859, who organized a Washington Statue Fair in the Music Hall from 16 to 24 November of that year, at which some $10,000 was made. After long delays caused by the Civil War and by the sculptor's absence in Italy, the Washington statue was finally cast, mounted, and dedicated in 1869. The total cost was $42,000, of which only $10,000 was appropriated by the city. Ball's plaster study for the Washington statue, given to the Boston Athenaeum in 1932, rides spiritedly down the center of the third floor reading room.

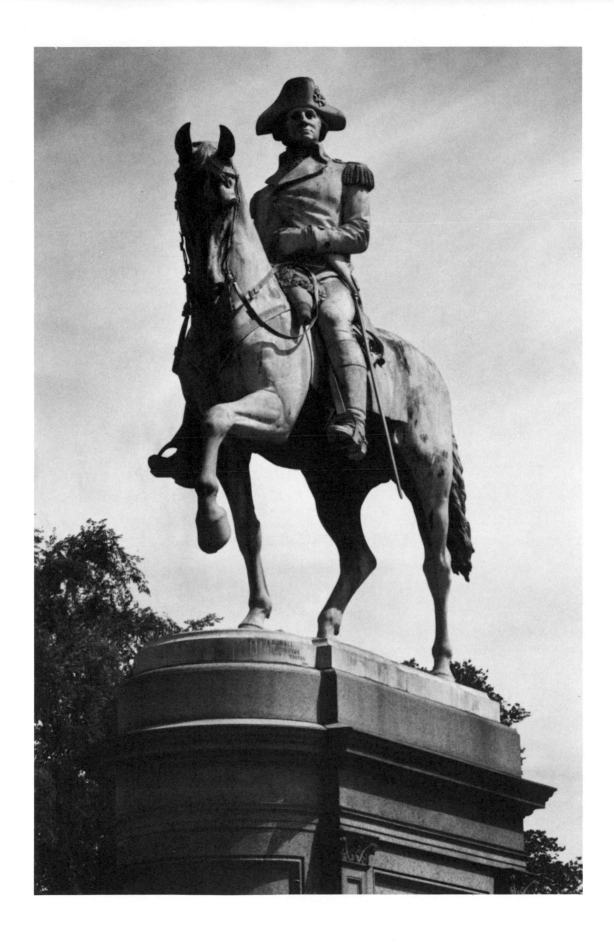

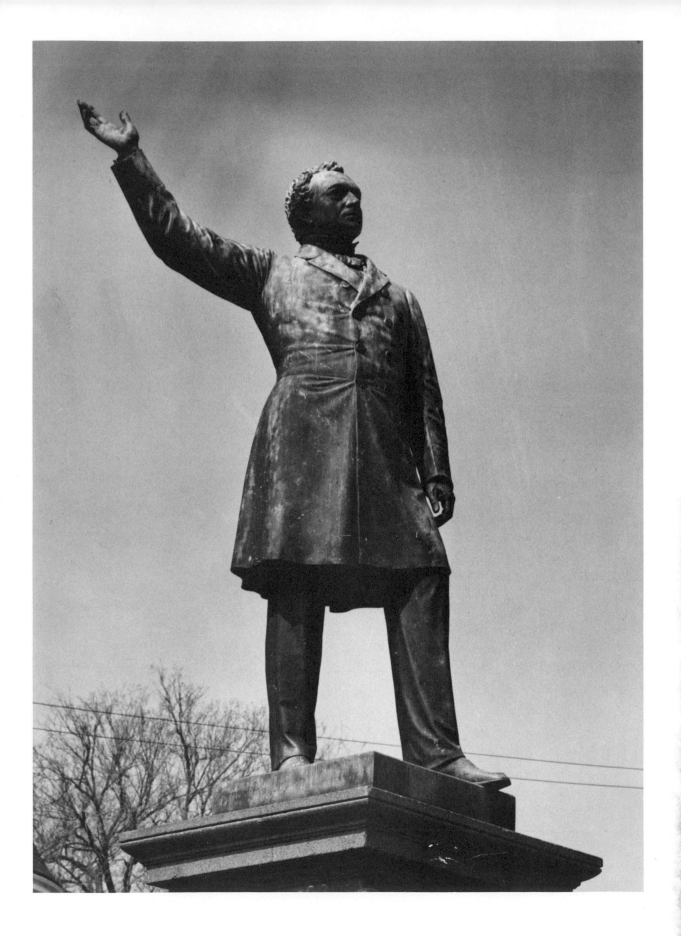

EDWARD EVERETT

Richardson Park, Dorchester

THE death of Edward Everett (1794–1865), Unitarian clergyman, Congressman, Governor of Massachusetts, Minister to Great Britain, President of Harvard, Secretary of State, Senator, and orator *par excellence*, produced such general sorrow that an Everett Statue Committee soon had far more money than was needed for a bronze statue by William Wetmore Story, which was modelled in Rome, cast in Munich, and set up in the Public Garden on 18 November 1867. The subscription was so generous that it provided in addition to the statue a bust by Thomas Ball, a portrait by Moses Wight, and $5,000 left over to help with the expenses of Ball's Washington as well as $7,500 for the new Museum of Fine Arts. However eminent the subject, Story's statue, with its upraised arm, was somewhat ridiculous. It was trucked off to Edward Everett Square, Dorchester, in 1911, removed as a traffic hazard in 1931, and only placed in its present location in Richardson Park, Dorchester, after passing four ignominious years on its back in the woodyard at Franklin Park.

JOHN ALBION ANDREW

State House

JOHN ALBION ANDREW (1818–1867), Civil War Governor of Massachusetts and one of the most effective supporters of the Union, died less than a year after his retirement from office. With the precedent of statues to commemorate Daniel Webster, Horace Mann, and Edward Everett, private citizens raised a subscription to procure a memorial that would show the affectionate regard of the people of Massachusetts for their late Governor. Thomas Ball, back from Italy on a visit, was asked to make a model for a statue in competition with several other artists. His design was chosen; the marble statue that was carved in 1870 was unveiled in Doric Hall at the State House on 14 February 1871. Although the statue is without classical embellishments, the folds of a voluminous cloak attempt to mitigate the severity of contemporary costume, but fail to conceal a pair of very unpressed trousers.

34

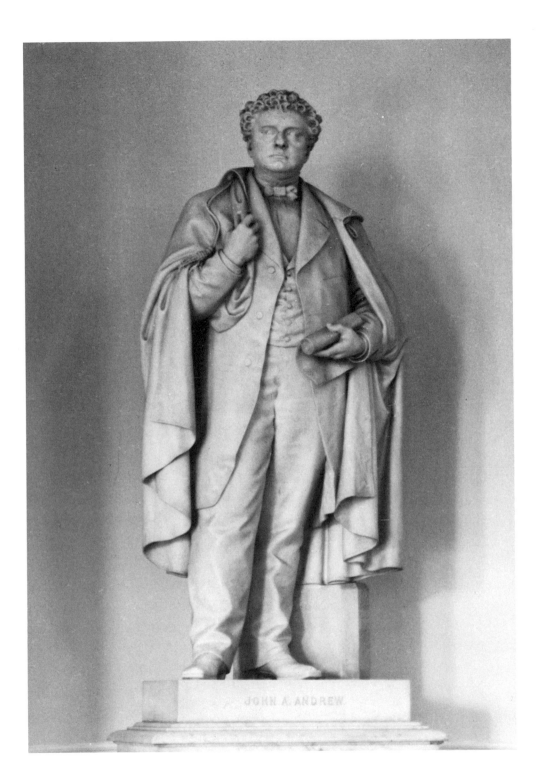

JOHN A. ANDREW.

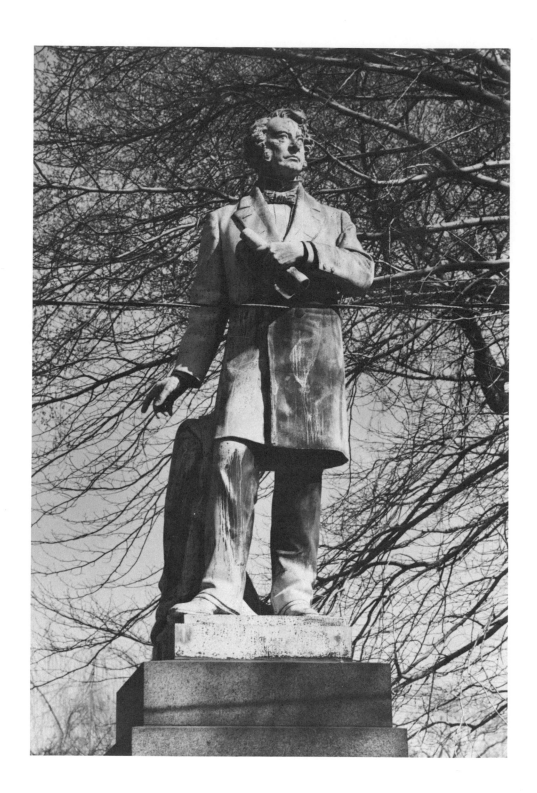

CHARLES SUMNER

Public Garden

Thomas Ball's bronze statue of Senator Charles Sumner (1811–1874) is a bold example of realism in costume, without recourse to toga or cloak. Ball received the commission for this statue during his visit to the Centennial Exposition in 1876. He worked on the model after his return to Florence, and sent it to Paris to be cast by the celebrated bronze-founder Barbedienne. On its completion it was shipped to Boston and placed in the Public Garden, looking out on Boylston Street, opposite number 270. It was unveiled on 23 December 1878, without formal ceremonies other than the reading of an historical sketch by Alexander H. Rice, then Governor of Massachusetts. Ball's Sumner is a less histrionic portrait of an orator than Story's Everett, which perhaps explains why it has stayed put for nearly a century.

EMANCIPATION GROUP

Park Square

A duplicate casting of Thomas Ball's Emancipation Group (originally executed for the Freedman's Memorial Society in Washington) was given to the city of Boston in 1877 by Moses Kimball and put up in Park Square. Of this group, Professor Chandler Rathfon Post observed in his *History of European and American Sculpture:* "The real merits of conscientious portraiture in Ball's own representation of Lincoln in the act of emancipating a slave, in Lincoln Park, Washington, are obscured by the unfortunate appearance that he has given to the negro of polishing the President's boots." Ball recalled in his autobiography that every cent of the $17,000 paid him for the Washington statue, which was completed in 1875, was contributed by freed men and women. Moses Kimball, who gave the Boston replica, was the proprietor of the theater known as the Boston Museum.

38

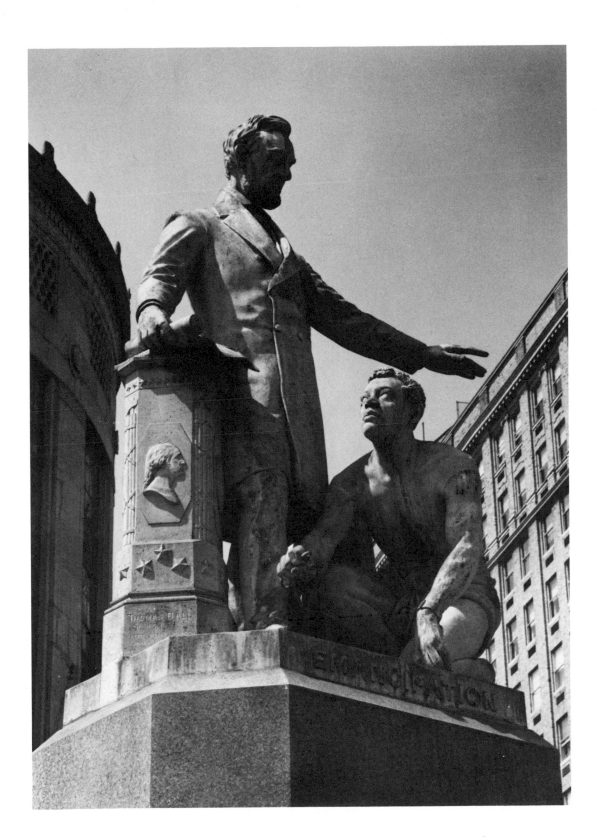

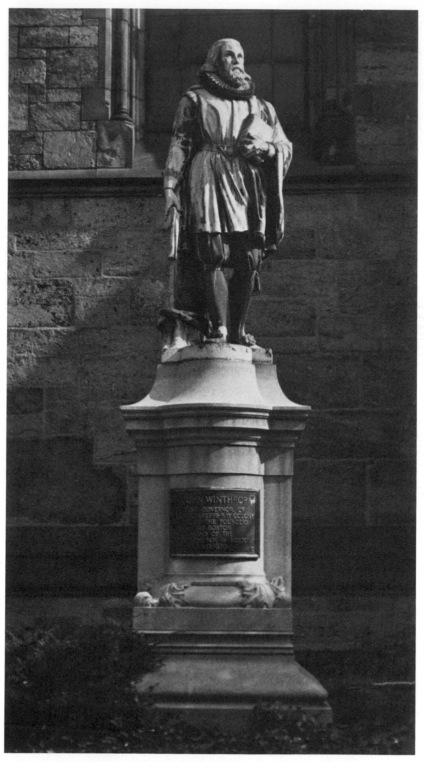

REPRODUCED BY COURTESY OF THE BOSTON ART COMMISSION FROM A PHOTOGRAPH MADE BY MRS. T. PERKINS PUTNAM BEFORE THE 1968 FIRE.

JOHN WINTHROP

First Church, Marlborough Street

Since the Commonwealth of Massachusetts had chosen as its two representatives in the Statuary Hall in the Capitol in Washington John Winthrop, Governor of the Massachusetts Bay Company at the settlement of Boston, and Samuel Adams, Revolutionary rabble-rouser and Governor of Massachusetts, 1794–1797, it was only appropriate that these worthies should be represented by replicas in Boston. Richard Saltonstall Greenough's marble Winthrop was placed in the Statuary Hall in 1876. A bronze replica of it, erected in the now vanished Scollay Square in 1880, was, because of increasing traffic, moved in 1903 to the side yard of the First Church in Marlborough Street, where memorials of the Puritan settlers of the Massachusetts Bay Company were cherished. It was seriously damaged in 1968 in a fire of unknown origin that destroyed the church.

41

SAMUEL ADAMS

Faneuil Hall

W HEN the Commonwealth of Massachusetts awarded the commission in 1873 for the statue of Samuel Adams that was destined for the Statuary Hall in the Capitol in Washington, it was stipulated that the carving should be done in Italy. The artist chosen was Anne Whitney (1821–1915), a self-taught native of Watertown, Massachusetts, who in the middle thirties of her long life had turned from poetry to modelling. Beginning with portrait busts of relatives and friends, she progressed to idealized figures of Lady Godiva, Africa, Toussaint L'Ouverture, and the Lotos Eater before undertaking this public commission. A bronze replica of her Samuel Adams, purchased by the city from the fund bequeathed by Jonathan Phillips, was in 1880 placed in Adams Square; in 1928 it was moved to its present location directly in front of Faneuil Hall.

42

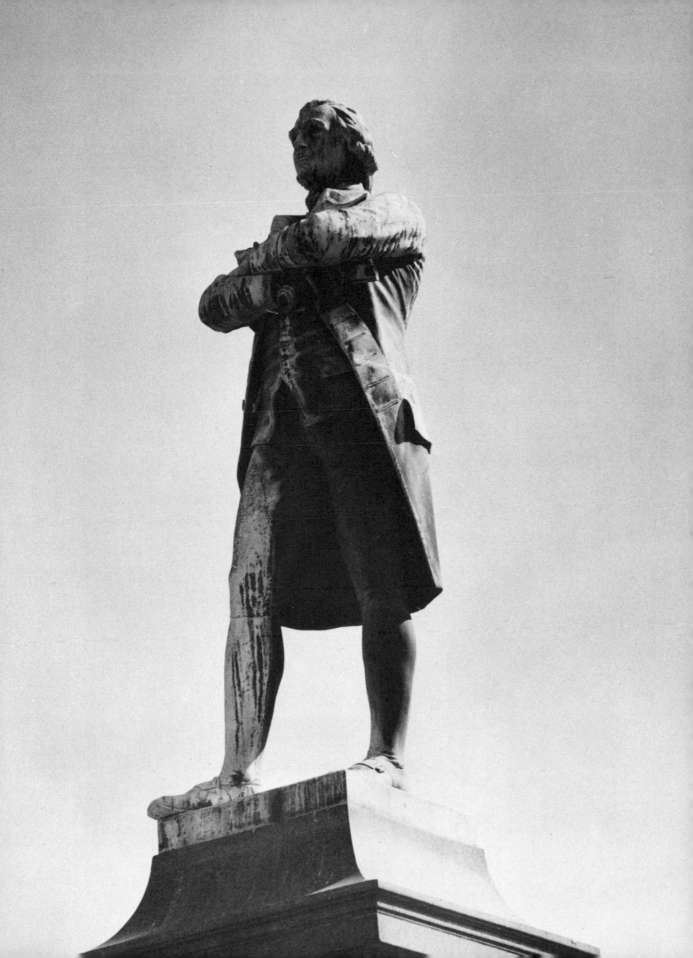

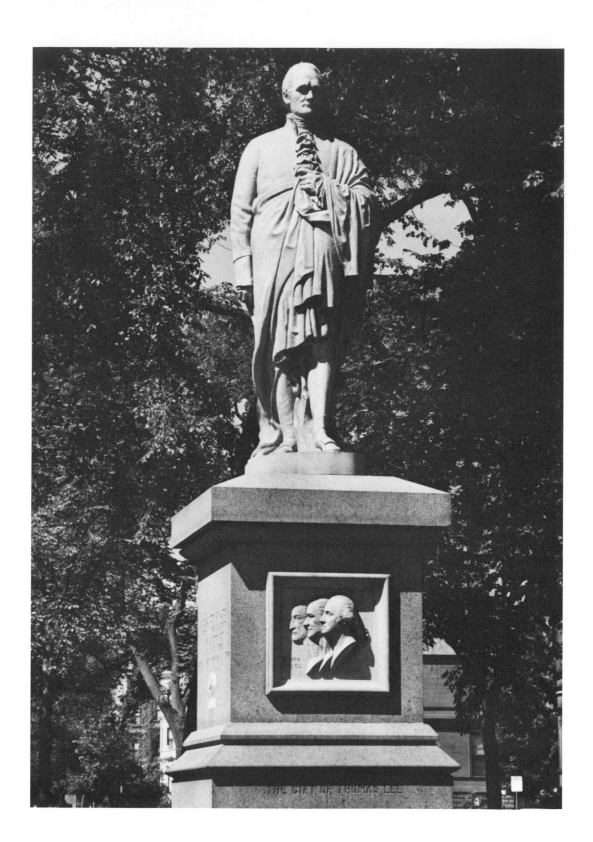

THE GIFT OF THOMAS LEE

ALEXANDER HAMILTON

Commonwealth Avenue

THE filling of the Back Bay, which began in the late 1850s, and the development of Commonwealth Avenue as a local approximation of a Parisian boulevard, furnished new sites for statues. In 1865 Thomas Lee gave the city a granite figure of Alexander Hamilton that was placed in the Commonwealth Avenue Mall between Arlington and Berkeley Streets. This was the creation of Dr. William Rimmer (1816–1879), a native of Liverpool who had been brought to Boston as a child. Although a physician with real genius as an anatomist, he eked out his living as a granite cutter, and through this sideline turned to sculpture. For the Hamilton statue Rimmer used no models, but carved directly in granite with no other guide than his knowledge of anatomy. His genius and methods were better adapted to nude rather than draped figures like this one.

45

JOHN GLOVER

Ten years later in 1875 Benjamin Tyler Reed gave a bronze statue of the Marblehead Revolutionary general, John Glover, to adorn the next block of the Commonwealth Avenue Mall. This was the work of Martin Milmore (1844–1883), a gifted pupil of Thomas Ball. Born in Sligo and brought from Ireland to Boston at the age of seven by his widowed mother, Milmore began when only fifteen to study with Ball. The acceptance by the city of Boston in 1867 of Martin Milmore's design for the Roxbury Soldiers Monument in Forest Hills Cemetery, when he was still in his early twenties, gave him a considerable local reputation. There a bronze soldier, resting on his gun, contemplates the graves of his fallen comrades. In this work, General Glover, sword in hand, with his left foot on a cannon, seems about to spring into vigorous activity.

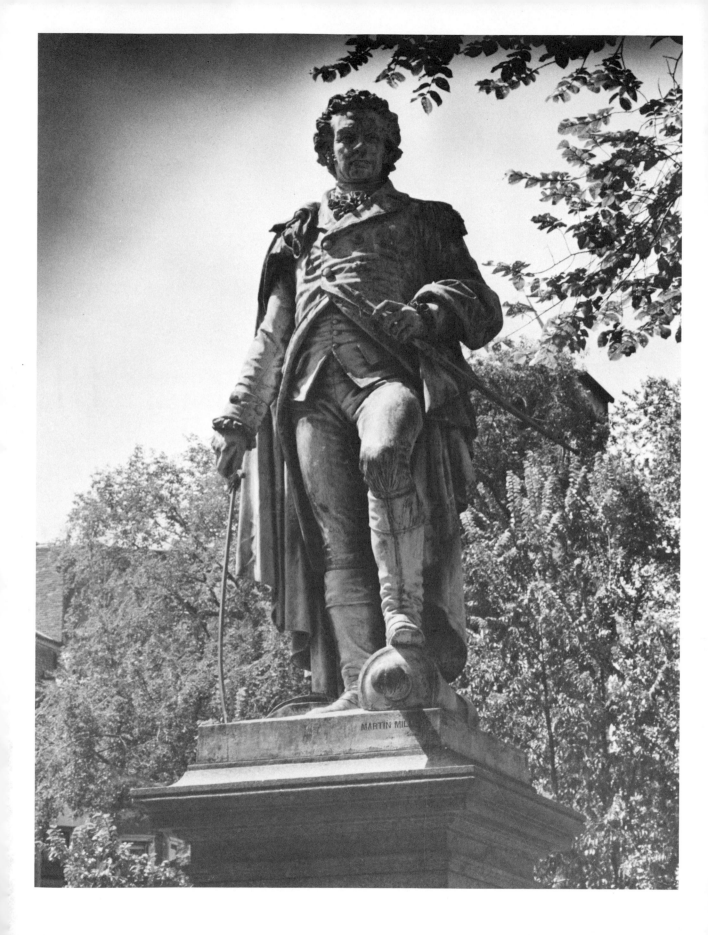

MARTIN MIL

SOLDIERS' AND SAILORS' MONUMENT

Boston Common

Martin Milmore's success with the Roxbury monument led to his doing the Soldiers' and Sailors' Monument atop Flagstaff Hill on Boston Common, begun in 1871 and completed in 1877. Four statues representing Peace, the Sailor, The Muse of History, and the Soldier, stand at the base of a tall column surmounted by a figure of Liberty. Between the projections on which the statues stand are four bronze reliefs depicting the departure of forces for the war, the Battle of Fort Sumter, the work of the Boston Sanitary Commission, and the return from the war. At the foot of the column stand allegorical figures in high relief representing the sections of the country, the North, South, East, and West. The architectural sense of the design is admirable. The presence of this collective monument did not, however, spare Boston a number of individual memorials of the Civil War.

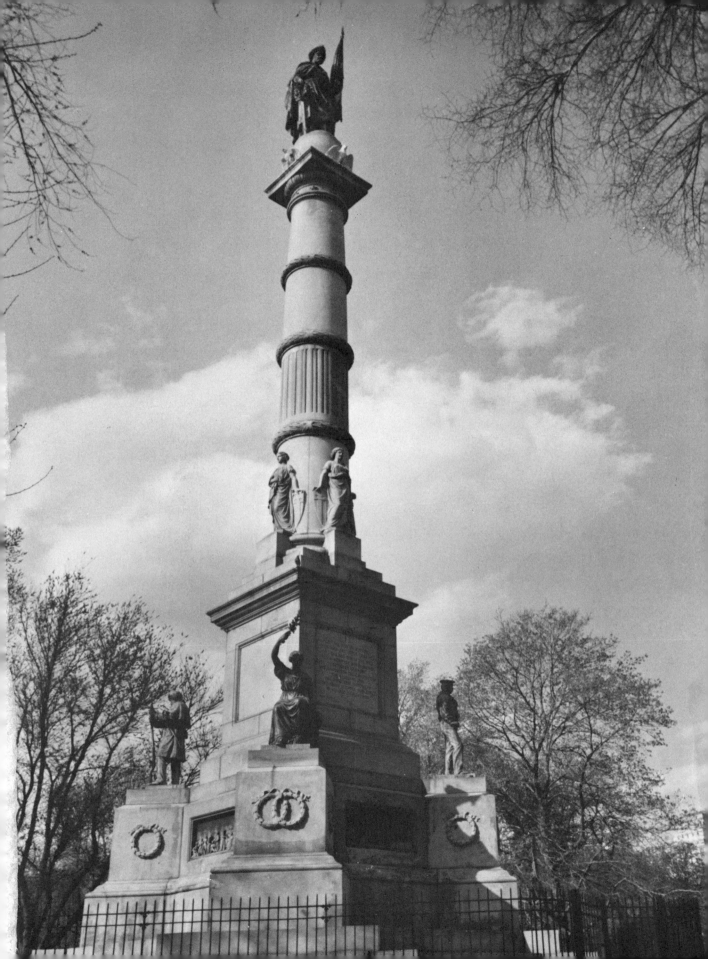

ROBERT GOULD SHAW AND THE
54TH MASSACHUSETTS REGIMENT

Beacon Street

THE finest of all the individual Boston memorials to participants in the Civil War is the great bronze bas-relief by Augustus Saint-Gaudens (1848–1907) that commemorates the twenty-six-year-old Colonel Robert Gould Shaw and the free negroes of the 54th Massachusetts Regiment who fell with him on 18 July 1863 in the assault on Fort Wagner, South Carolina. The monument stands on the south side of Beacon Street, facing the State House, past which this first black regiment marched on 28 May 1863 to salute Governor John A. Andrew as it was about to embark for South Carolina. Although Governor Andrew called a meeting in the fall of 1865 to procure an equestrian statue of Shaw by William Wetmore Story, the effort dragged. In 1884 when Saint-Gaudens was given the commission he proposed a bas-relief, but was so incredibly slow in its completion that the monument was only dedicated on 31 May 1897. It was fine enough to have been worth waiting for.

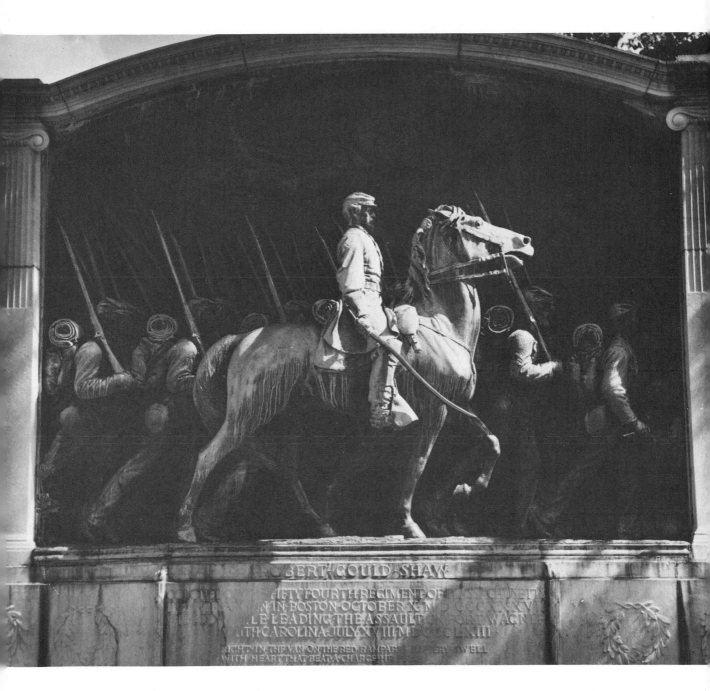

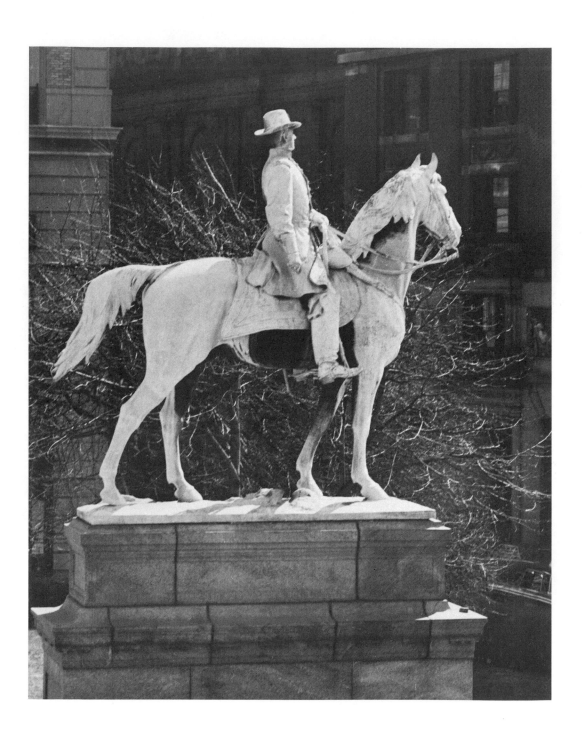

JOSEPH HOOKER

State House

Diagonally across from the Shaw monument, at the entrance to the east wing of the State House, stands the equestrian statue of Major General Joseph Hooker, who as commander of the Army of the Potomac was defeated by Lee at Chancellorsville on 2–4 May 1863 despite a two-to-one superiority in numbers. The Commonwealth appropriated funds in 1896 for the statue, dedicated on 25 June 1903. The man is the work of Daniel Chester French (1850–1931); the horse, of Edward C. Potter. Of this monument Charles Francis Adams (1835–1915), a Civil War brevet brigadier general, wrote: "Never since it has been placed there have I passed by the front of the State House without feeling a sense of wrong and insult at the presence, opposite the head of Park Street, of the equestrian statue of Hooker. That statue I look upon as an opprobrium cast on every genuine Massachusetts man who served in the Civil War. Hooker in no way and in no degree represents the typical soldiership of the Commonwealth."

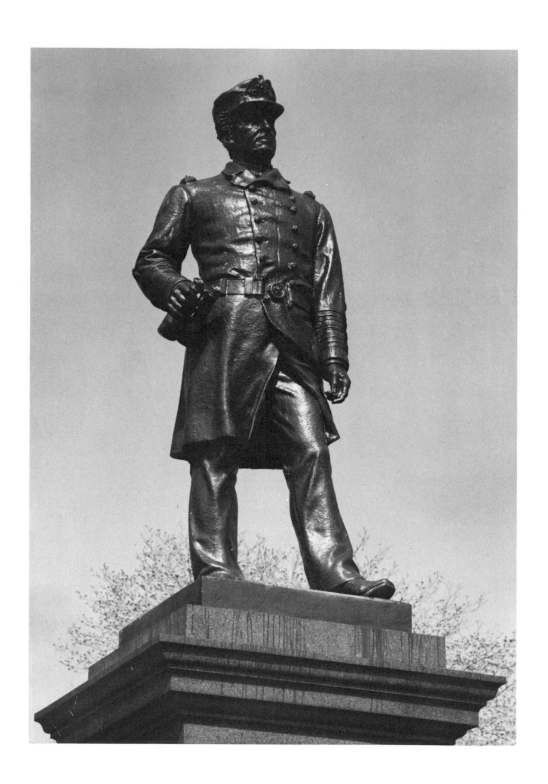

DAVID GLASGOW FARRAGUT

Marine Park

For a seaport, Boston has an odd way of turning its back upon its fine harbor, yet the bronze statue of Admiral David Glasgow Farragut, commissioned by the city, was appropriately placed in Marine Park, South Boston, within sight of the sea, on petition of the South Boston Citizens Association. It was the work of the English-born sculptor, Henry Hudson Kitson (1860–1947). Its dedication on 28 June 1893 was celebrated by a parade that included South Boston letter carriers in horse-drawn coaches—just why is not clear—and a float representing Farragut's flagship *Hartford*, manned by forty-four pretty girls representing the states of the Union. The Russian Atlantic Squadron being in Boston on the occasion, its commander, N. Zelonoy, made an address with graceful reference to Admiral Farragut's visit to Russia in 1867 during his last cruise in command of the European Squadron.

CHARLES DEVENS

Charles River Esplanade

I n the fifteen years following the dedication of the Farragut monument, the Commonwealth of Massachusetts appropriated funds for the erection of statues of three Civil War generals beside Hooker. Major General Charles Devens was commemorated by a bronze statue by Olin L. Warner (1844–1896) that was placed near Bowdoin Street in the State House grounds. Devens was a respected Worcester lawyer who was commissioned a major in 1861, served actively throughout the war, being brevetted a major-general in 1865. Subsequently he was a judge of the Massachusetts Supreme Judicial Court and Attorney-General in President Hayes's cabinet. In 1917 the New England army camp near Ayer, Massachusetts, was named in his honor. The creation of a State House parking lot in 1950 caused the banishment of General Devens's statue to the Charles River Esplanade at the foot of Beacon Hill.

56

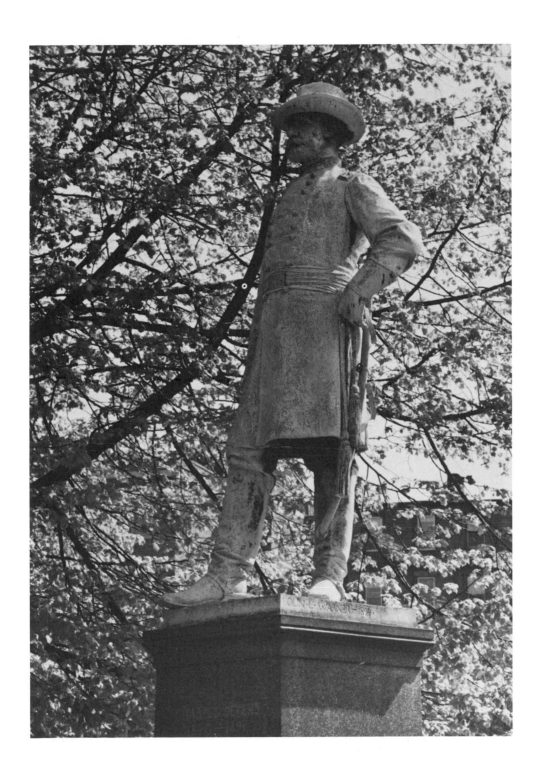

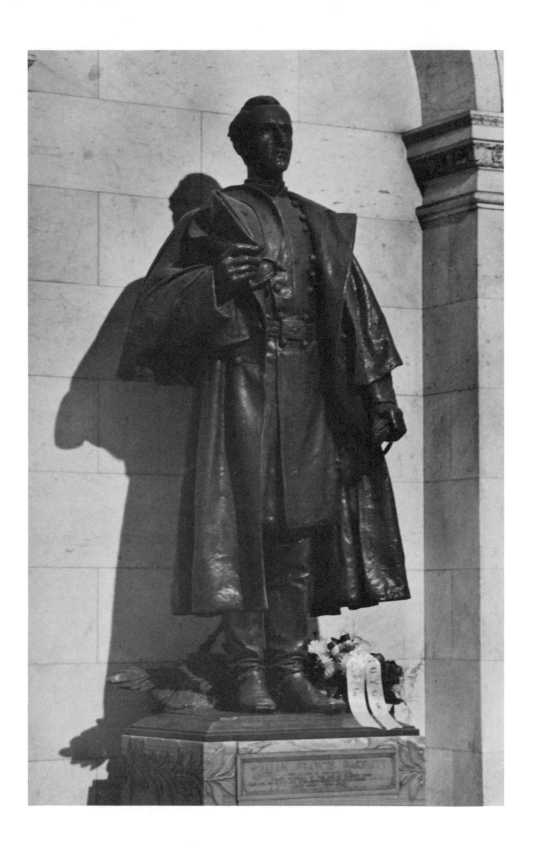

WILLIAM FRANCIS BARTLETT

Another refugee from the black-topping of a State House parking lot was Henry Hudson Kitson's bronze statue of Nathaniel Prentiss Banks, who was Governor of Massachusetts 1858–1861 and Major General of U.S. Volunteers during the Civil War, and for whom Fort Banks in Winthrop was named. Authorized in 1897 and dedicated in 1908, the statue was in 1950 trucked off to Waltham, its subject's birthplace, and is therefore not illustrated here. Daniel Chester French's bronze of Major General William Francis Bartlett saluting the colors, having been intended, by act of 1901, for the State House grounds, avoided similar deportation only because in 1903 the Governor and Council voted that it be placed indoors, in Memorial Hall with the Civil War battle flags, where it still is. Bartlett, born in 1840, volunteered at the outbreak of the war, was a major general at the age of twenty-four, and died in 1876. He is a handsome figure.

THOMAS CASS

THE incident of the statue of Colonel Thomas Cass, a native of Ireland, who was killed at Malvern Hill on 1 July 1862 at the head of his "Fighting Ninth" Massachusetts regiment, illustrates the Boston desire to reconcile piety and aesthetics. A granite statue of him, placed in the Public Garden in the last decade of the nineteenth century, left so much to be desired that the city replaced it by a more reputable bronze by Richard E. Brooks, at the expense of a fund bequeathed to the city by Jonathan Phillips. When the replacement was dedicated in 1899, in the presence of the subject's son and daughter, and surviving members of the regiment, Mayor Josiah Quincy (the third of his name) declared that "it represents Colonel Cass as a type of Irish soldier in the Rebellion; it is also the type of the Northern soldier without distinction of race."

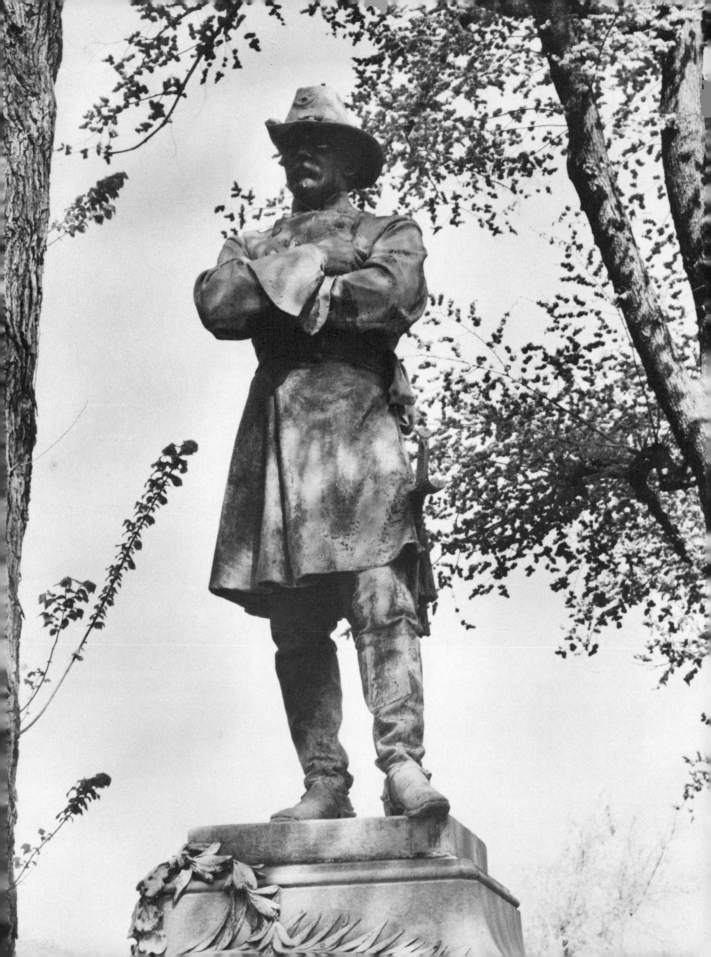

WILLIAM LLOYD GARRISON

Commonwealth Avenue

Civil and religious, as well as military, heroes were commemorated by Boston statues during the last decades of the nineteenth century and early years of the twentieth. Some of them represented startling changes in public sentiment. In 1835 a Boston mob had dragged the abolitionist-reformer William Lloyd Garrison (1805–1879) through the streets with a rope around his neck; the rope might have been tightened had it not been for the courageous intervention of Mayor Theodore Lyman. Half a century later a public subscription was being raised in Boston for a monument to Garrison. The seated bronze statue of him by Olin Levi Warner (1844–1896) was unveiled in 1886 in the Commonwealth Avenue Mall, where it keeps curious company with the likenesses of Alexander Hamilton and General John Glover.

62

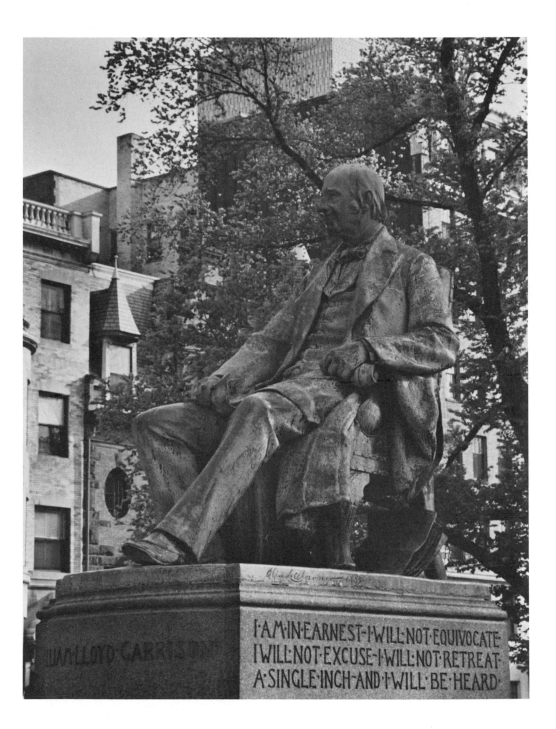

I AM IN EARNEST · I WILL NOT EQUIVOCATE ·
I WILL NOT EXCUSE · I WILL NOT RETREAT ·
A SINGLE INCH · AND I WILL BE HEARD

WILLIAM LLOYD GARRISON

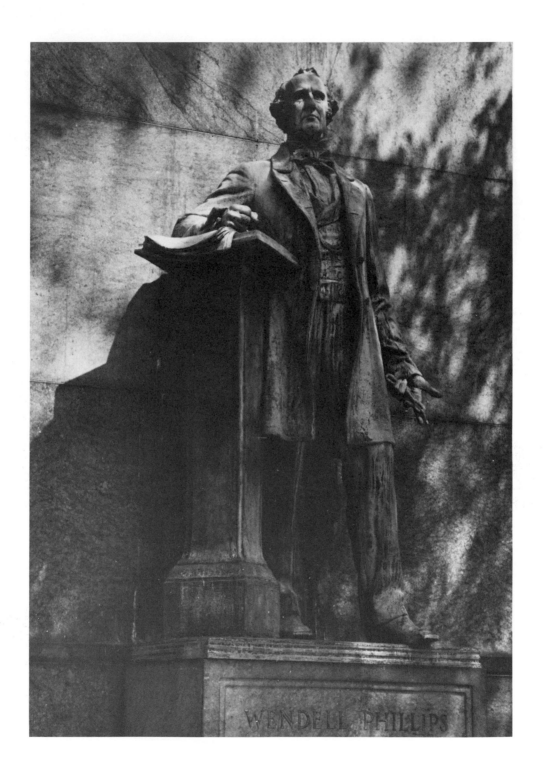
WENDELL PHILLIPS

WENDELL PHILLIPS

Public Garden

WHEN Thomas Ball came back to Boston in 1879, the abolitionist orator Wendell Phillips (1811–1884) expressed the hope that he "would go to heaven soon" and sent him away, as Ball recalled in his autobiography, "with his exceedingly vulgar tirade against me and the Boston statues ringing in my ears,—as if I had made them all!" Ball's pupil, Martin Milmore, had done a bronze bust of Wendell Phillips in 1869, subsequently in 1903 presented to Faneuil Hall by the clothier A. Shuman, but neither Ball nor any one else risked attempting a statue of the sharp-tongued orator in his lifetime. Nevertheless the City Council in 1913 appropriated $20,000 for such a monument, which was executed, without fear of abuse, by Daniel Chester French. Placed in the Public Garden on the Boylston Street Mall, it was dedicated on 4 July 1915.

65

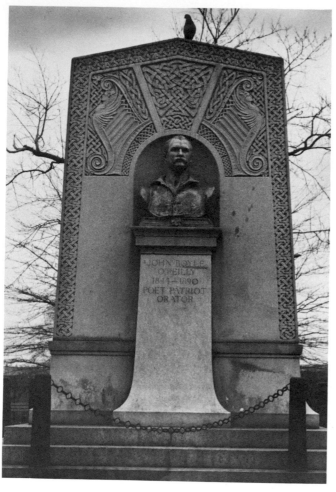

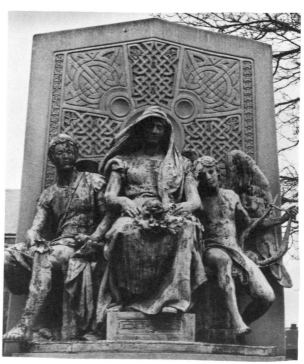

JOHN BOYLE O'REILLY MEMORIAL

The Fenway

THE moving quality of Daniel Chester French's great allegorical relief, "Death staying the hand of the young sculptor," exhibited at the Paris Salon in 1892 and created for the grave of Martin Milmore in Forest Hills Cemetery in Boston, caused French soon after to receive the commission for the memorial then being proposed in Boston by public subscription to another native of Ireland, John Boyle O'Reilly (1844–1890), poet, patriot, naturalized Bostonian, and editor of *The Pilot*. For this monument, which was installed in the Fenway at the head of Boylston Street in 1896, Daniel Chester French created a double design. On one face is a bronze bust of O'Reilly set against a stone background of Celtic interlaces; on the other is a bronze personification of Erin, supported by allegorical figures representing her sons, Courage and Poetry.

67

RUFUS CHOATE

Suffolk County Court House

Daniel Chester French, a native of Exeter, New Hampshire, in the fruitful career that extended from the dedication of his symbolic Minute Man at Concord Bridge on the 1875 centenary of the battle to the unveiling of his colossal seated statue of Lincoln in Washington in 1922, was responsible for a great variety of memorials, including the idealized seated bronze statue of John Harvard that he created for Harvard College in 1884. In mid-career he produced the straightforward portrait statue of Rufus Choate (1799–1859), Massachusetts lawyer, statesman, and friend of Daniel Webster, that stands in the central hall of the Suffolk County Court House in Pemberton Square. This was the gift of George B. Hyde in 1898.

68

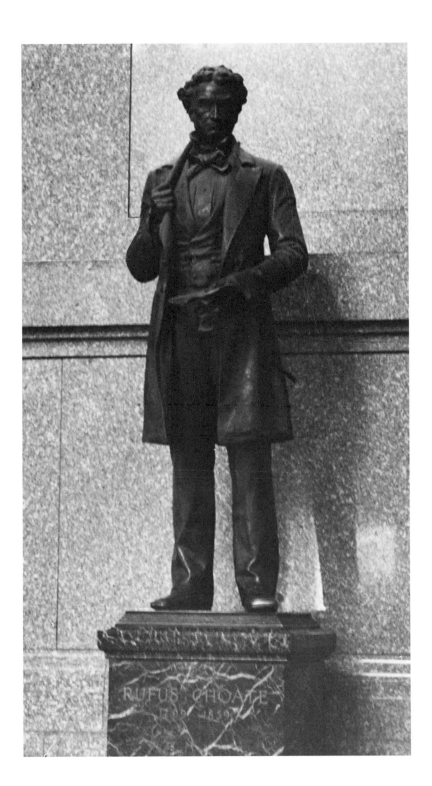

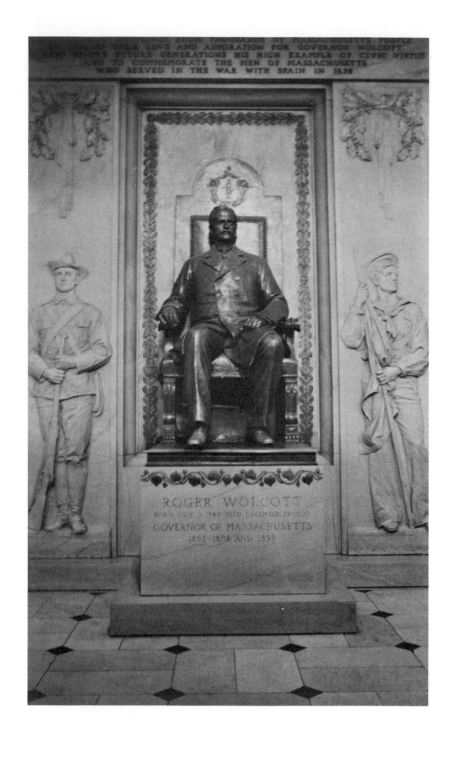

ROGER WOLCOTT

State House

THE untimely death in 1900 of Governor Roger Wolcott was so widely regretted that voluntary offerings from thousands of Massachusetts people poured in for a memorial to him. This took the form of a seated bronze portrait statue of heroic size, executed by Daniel Chester French, that stands on the third floor of the State House opposite the main staircase. As he had been Governor during the Spanish-American War, the memorial also commemorates the Massachusetts men who served in that conflict. The statue is placed against an architectural background designed by Henry Bacon (who later designed the Lincoln Memorial in Washington), and is flanked by marble pilasters on which French carved figures representing the typical soldier and sailor of the war. It was dedicated on 31 December 1906.

PATRICK ANDREW COLLINS

Commonwealth Avenue

A similar outpouring of popular sorrow led to the monument to Patrick Andrew Collins (1844–1905) that was placed in Commonwealth Avenue at Charlesgate West in 1908. This "talented honest generous serviceable man," born in Ireland, was successively an upholsterer, lawyer, member of the Massachusetts Legislature and the U.S. Congress, Consul General in London, and Mayor of Boston 1902–1905. When he died suddenly in 1905, a meeting was called in Boston to discuss means of perpetuating his memory. In six days the funds necessary for a statue were raised, and the commission given to Henry Hudson Kitson and his wife Theo Alice Ruggles Kitson (1863–1947), who executed a bust on a high pedestal, flanked by mourning figures of Columbia and Erin. The monument was moved sixty years later to the Commonwealth Avenue Mall, between Clarendon and Dartmouth Streets.

72

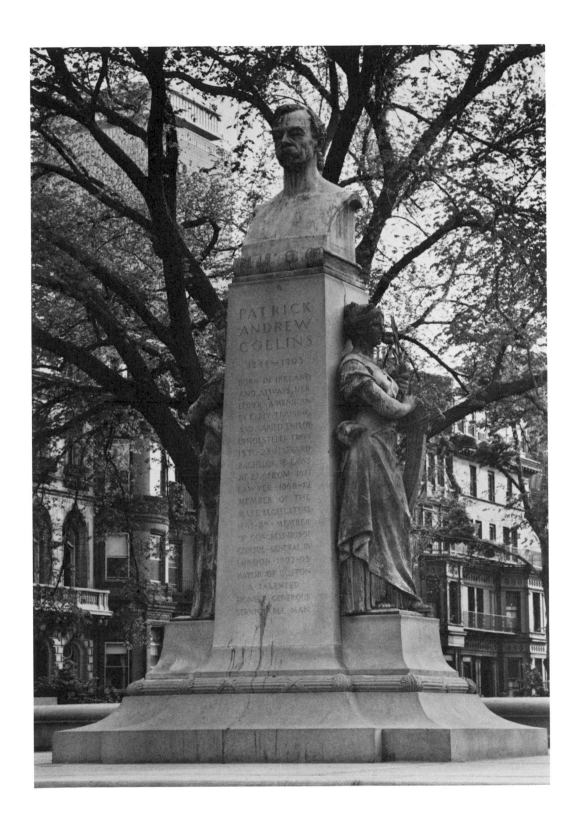

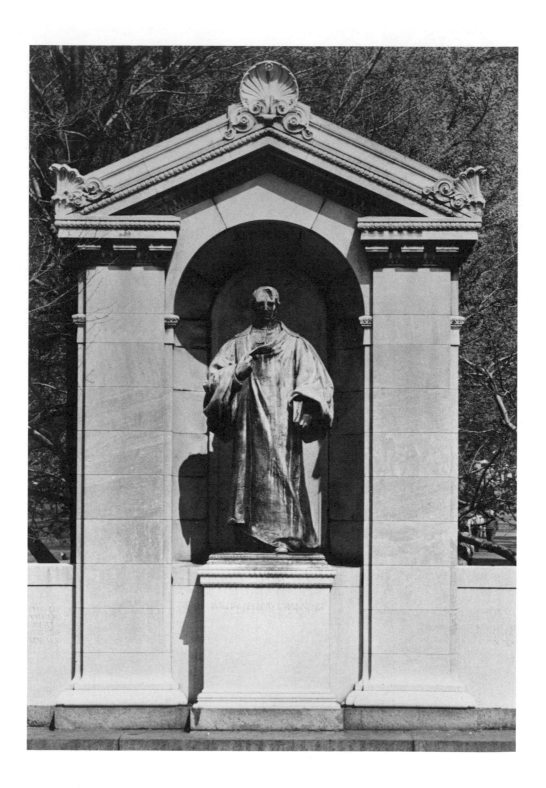

WILLIAM ELLERY CHANNING

Opposite Arlington Street Church

THREE Boston clergymen became statues in the early years of the twentieth century. John Foster bequeathed $30,000 for a statue of the Reverend William Ellery Channing (1780–1842), the much beloved Unitarian divine who was minister of the Federal Street Church in Boston from 1803 until his death. With the rapid growth of the city in the second quarter of the nineteenth century, Federal Street ceased to be a residential district. Channing's congregation migrated to the new Back Bay and built in 1859 the present Arlington Street Church at the corner of Boylston Street. The bronze statue of Channing that Herbert Adams (1858–1945) modelled in 1902 was, in accordance with Foster's will, placed directly opposite the Arlington Street Church, and was dedicated on 1 June 1903.

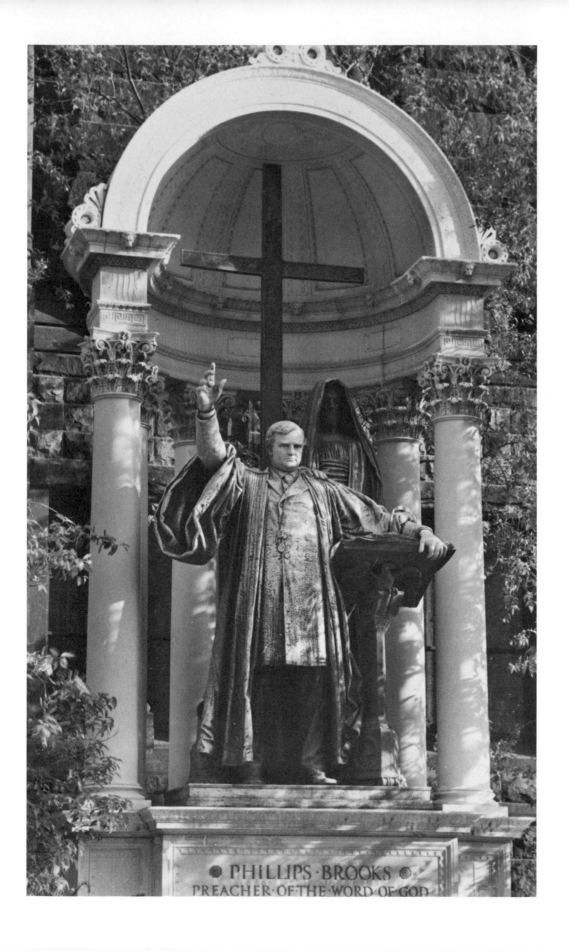

PHILLIPS · BROOKS ·
PREACHER · OF · THE · WORD · OF · GOD

PHILLIPS BROOKS

Trinity Church

Immediately after the death of the Right Reverend Phillips Brooks (1835–1893), Episcopal Bishop of Massachusetts, a popular subscription was opened for a statue of him. As Augustus Saint-Gaudens, who was commissioned to execute it, seldom moved rapidly, the monument was only placed outside the north transept of Trinity Church in Copley Square in 1910. It is not the happiest of that sculptor's efforts. As the bishop is preaching with fervor, his gown has fallen away to reveal rather too much frock coat, while a shrouded Christ, who places his hand on the preacher's shoulder, has been likened by the irreverent to a policeman interrupting a soapbox orator. Moreover the Renaissance baldachino that frames the group has all too little relation to the Romanesque boldness of H. H. Richardson's church against which it is set.

77

EDWARD EVERETT HALE

THE robed Channing stands sedately in a niche opposite Arlington Street Church as a hieratic Unitarian saint; Bishop Brooks vigorously exhorts passersby in Copley Square; but the Reverend Edward Everett Hale (1822–1909), author and Unitarian clergyman, is simply going for a walk in the Public Garden in civilian clothes, hat and stick in hand. This heroic size bronze statue, the result of a subscription among citizens, was the work of Bela Lyon Pratt (1867–1917), long a teacher of sculpture at the Museum of Fine Arts School. It was placed near the central entrance from Charles Street to the Public Garden in 1913 on so low a pedestal that Dr. Hale seems about to step down and start off for the miniature suspension bridge across the pond in the direction of Commonwealth Avenue.

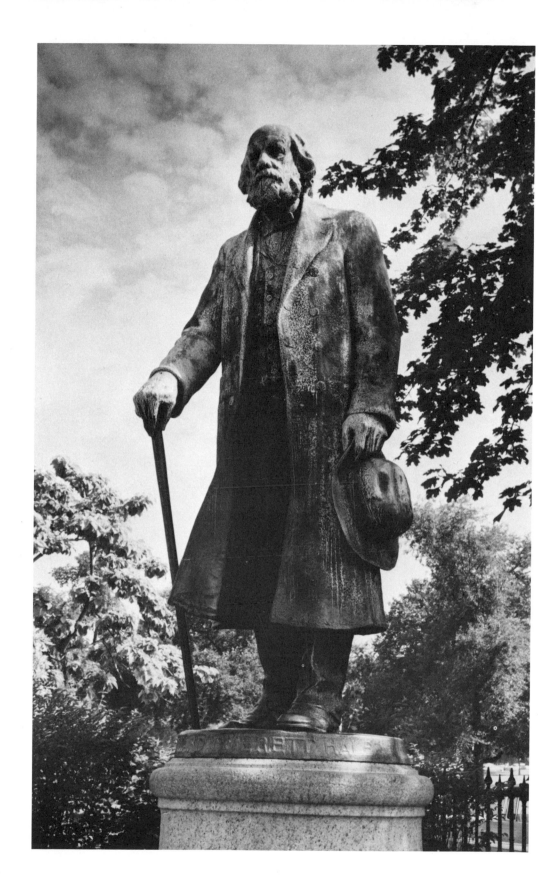

LEIF ERIKSSON

Historical fantasy entered the ranks of Boston statues on 29 October 1887 when a bronze figure of Leif Eriksson by Anne Whitney was unveiled in Commonwealth Avenue at Charlesgate. This was the personal whim of Eben N. Horsford, manufacturer of a patent indigestion cure called Horsford's Acid Phosphate, who by means of the statue sought to reinforce his belief that the Vinland of the Norse discoverers of America was located on the Charles River at Gerry's Landing in Cambridge. His theories were ill received, and the erection of the statue only added fat to the fire. Anne Whitney depicted Leif shading his eyes to look west into the sun setting over the Charles River. Now, alas, through recent highway construction, he peers into nothing more poetic than a vast overpass that siphons automobiles from the Fenway to the Storrow Drive.

80

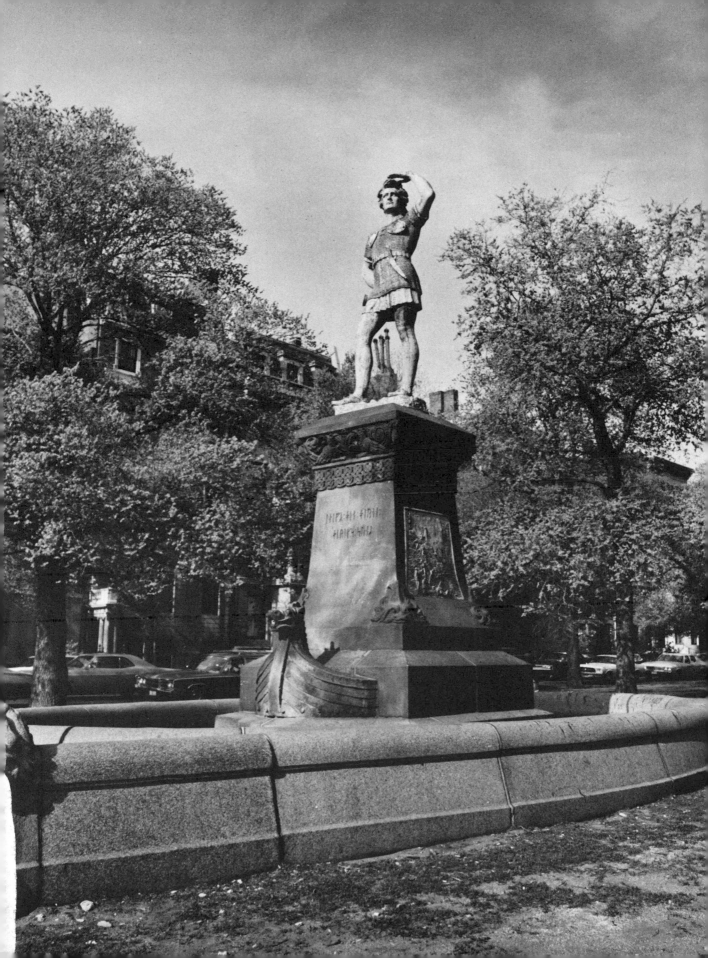

BOSTON MASSACRE MONUMENT

Boston Common

Whatever its historical validity may be, the statue of Leif Eriksson is attractive, which cannot be said of the Boston Massacre monument, executed by Robert Kraus (1850–1902) that the Commonwealth erected on Boston Common the following year. Against a tapering column, ringed by thirteen stars and inscribed with the names of the five street brawlers who stopped British bullets, stands an allegorical figure holding in one hand a broken chain and in the other a flag about to be unfurled, while an eagle tenses himself to fly. Below is a bronze bas-relief of the event commemorated. As it has become a popular diversion to shake hands with Crispus Attucks, the black man or Indian who was the first to be killed, so many people have done so that one hand on the relief is brightly polished and not at all dark.

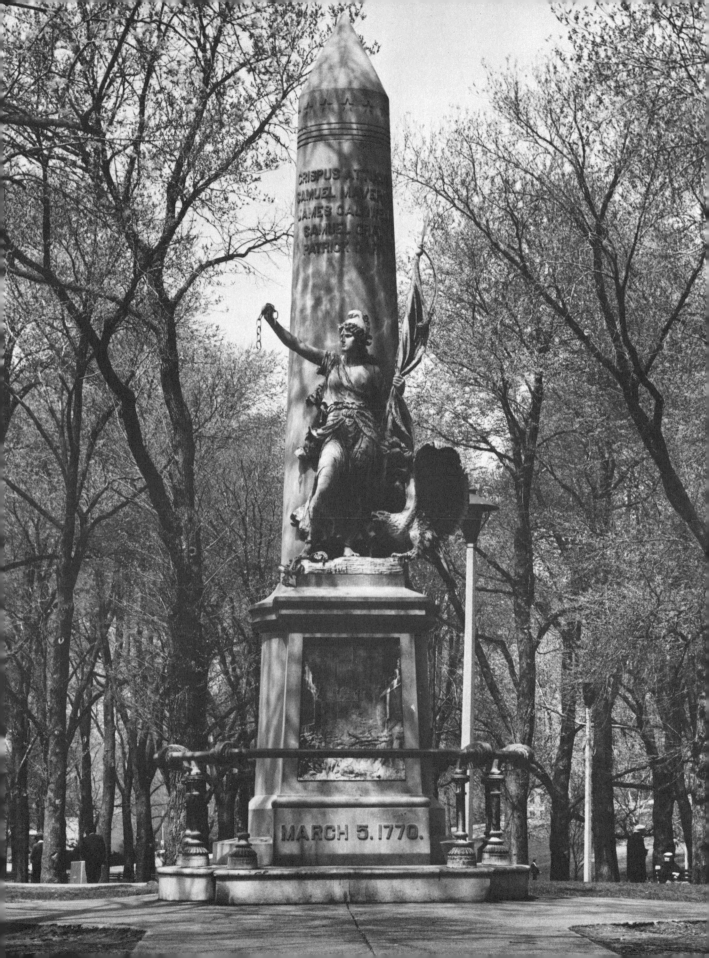

CRISPUS ATTUCKS
SAMUEL MAVERICK
JAMES CALDWELL
SAMUEL GRAY
PATRICK CARR

MARCH 5, 1770.

THEODORE PARKER

First Church, West Roxbury

A seated bronze statue of the Reverend Theodore Parker (1810–1860), executed by Robert Kraus in 1887, has enjoyed less visibility than his Massacre monument. Funds for this memorial to the Unitarian clergyman, abolitionist, and friend of John Brown of Ossawatomie, were raised by public subscription in the expectation that it would be placed in the Public Garden. Just as Theodore Parker had aroused controversy in his life, so did his likeness years after his death. As the Boston Art Commission declined to accept it for the city, the statue languished for some years in a storage warehouse. Early in 1902, however, members of the First Church in West Roxbury, where Parker had been minister from 1837 until 1845, rescued it and set it up in the grounds of their church.

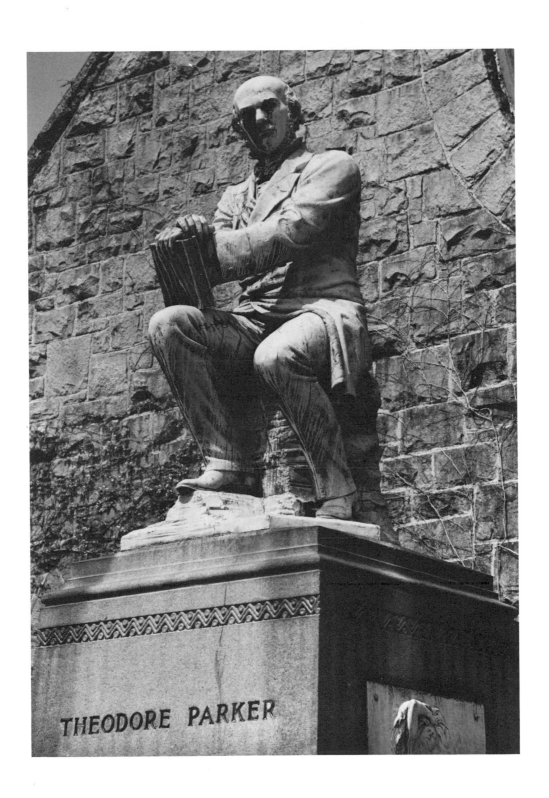

THEODORE PARKER

CHRISTOPHER COLUMBUS

THE answer to Eben Horsford's statue of Leif Eriksson was only five years in coming, for in 1892 the Knights of Columbus presented to Archbishop Williams an enormous statue of Christopher Columbus that was placed with great ceremony outside the Cathedral of the Holy Cross in Washington Street in the South End. This bronze by Alois G. Buyens was dedicated on 21 October 1892 in the course of a giant civic-religious observance that included bands, parades, and oratory. It was not a very inspired piece of sculpture; moreover, its appearance in relation to the façade of the cathedral left something to be desired. So, some thirty years later, presumably at the direction of Cardinal O'Connell, a man of taste, it was trucked off to Revere and placed in front of St. Anthony's Church, where it is balanced by an equally massive statue of St. Anthony of Padua.

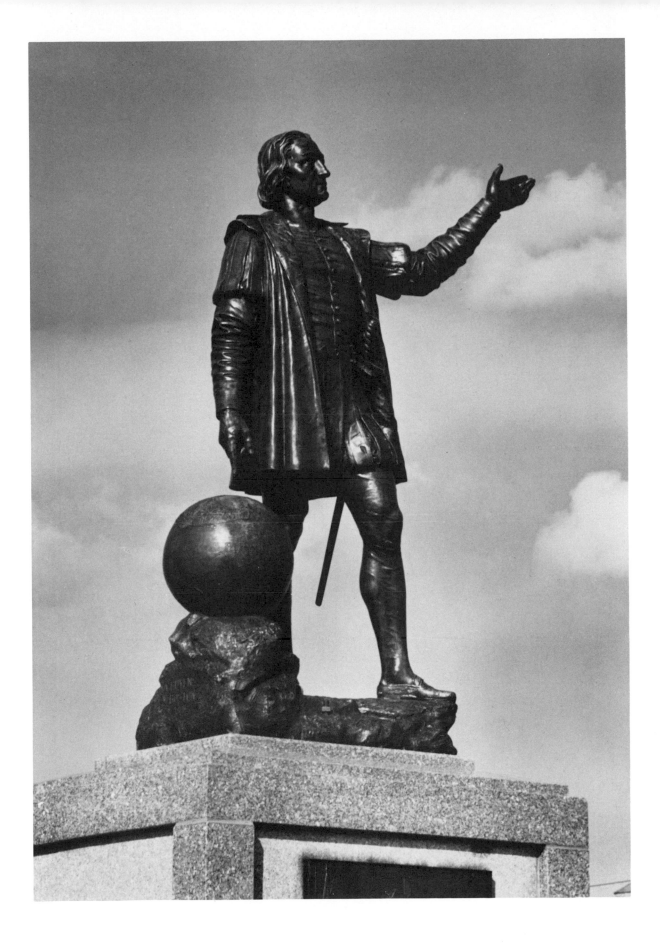

SIR HENRY VANE

Boston Public Library

Most of the remaining statues of the late nineteenth and twentieth centuries are of colonial or Revolutionary subjects. Sir Henry Vane (1613–1662) arrived in Massachusetts in October 1635 and left for good in August 1637. He was elected Governor at the age of twenty-three when he had been in the colony less than eight months. A bronze statue of him by Frederic Macmonnies (1863–1937) stands in a vestibule niche of the Boston Public Library. Charles F. McKim's design for the building called for a liberal use of painting and sculpture. The Reverend James Freeman Clarke, a trustee of the library, admired Vane as a defender of civil liberty and toleration. To keep everyone happy, Dr. Charles Goddard Weld, an amiable and generous collector of Japanese art, obliged by giving the statue.

88

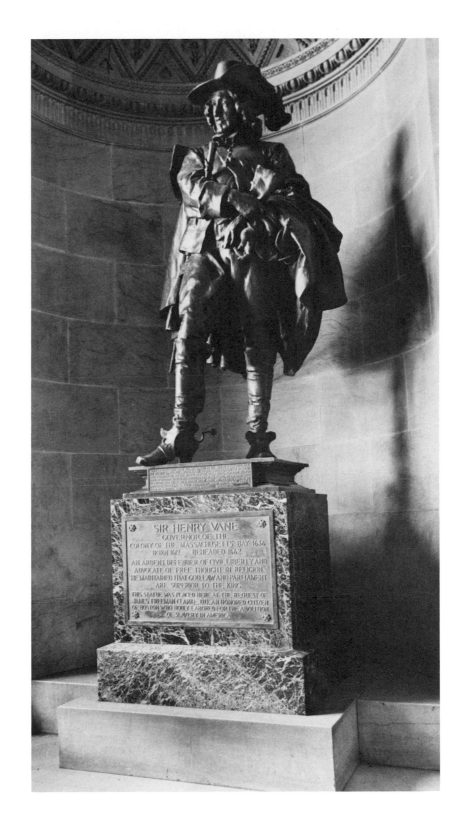

SIR HENRY VANE
GOVERNOR OF THE
COLONY OF THE MASSACHUSETTS BAY 1636
BORN 1612 BEHEADED 1662
AN ARDENT DEFENDER OF CIVIL LIBERTY AND
ADVOCATE OF FREE THOUGHT IN RELIGION
HE MAINTAINED THAT GOD, LAW AND PARLIAMENT
ARE SUPERIOR TO THE KING
THIS STATUE WAS PLACED HERE AT THE REQUEST OF
JAMES FREEMAN CLARKE, D.D. AN HONORED CITIZEN
OF BOSTON WHO NOBLY LABORED FOR THE ABOLITION
OF SLAVERY IN AMERICA

JOSEPH WARREN

Bunker Hill

THE cornerstone of the Bunker Hill Monument in Charlestown, which long dominated the Boston skyline, as the Washington Monument did that of the nation's capital, was laid on 17 June 1825, the fiftieth anniversary of the battle. It was 1842 before the capstone of this great obelisk, designed by Solomon Willard, was put in place. Thereafter the Bunker Hill Monument Association sought to commemorate individually some of the participants in the battle. In 1850, on the seventy-fifth anniversary, the Association voted to procure a statue of Dr. Joseph Warren (1741–1775), who, although elected a major general by the Provincial Congress, was killed while serving as a volunteer at Bunker Hill. A white marble statue by Henry Dexter (1806–1876) of Cambridge was unveiled on the grounds with considerable ceremony on 17 June 1857.

90

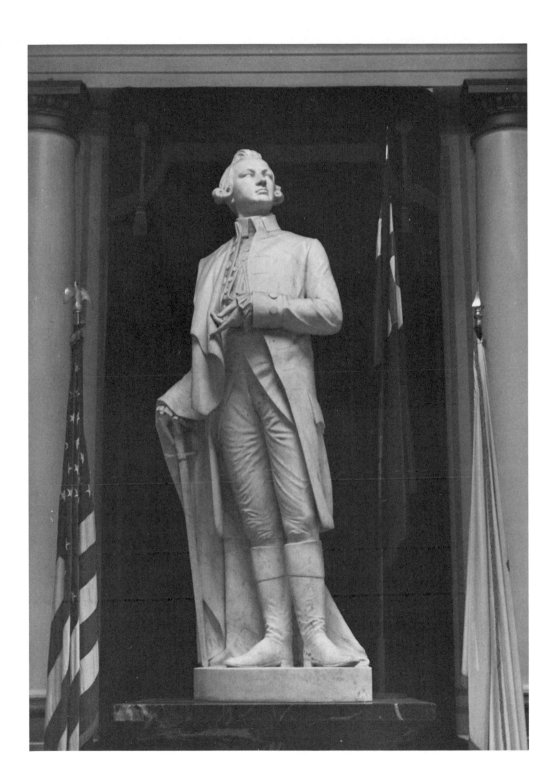

JOSEPH WARREN

Roxbury Latin School

Like George Washington, Dr. Joseph Warren is a two-statue man, for the monument to him at Charlestown, where he died, did not satisfy the filial piety of twentieth century residents of Roxbury, where he had been born. Consequently in 1904 a bronze statue of him by Paul Wayland Bartlett (1865–1925) was set up on Warren Street in Roxbury. It remained there for over sixty years until changes in the street pattern by the Boston Redevelopment Authority caused its removal to storage in Franklin Park. As Warren had been a graduate of and master at the Roxbury Latin School, that ancient institution rescued the statue in the summer of 1969 and set it up on the school grounds in West Roxbury, where it was formally dedicated on 8 May 1970 as a part of the school's 325th Convocation.

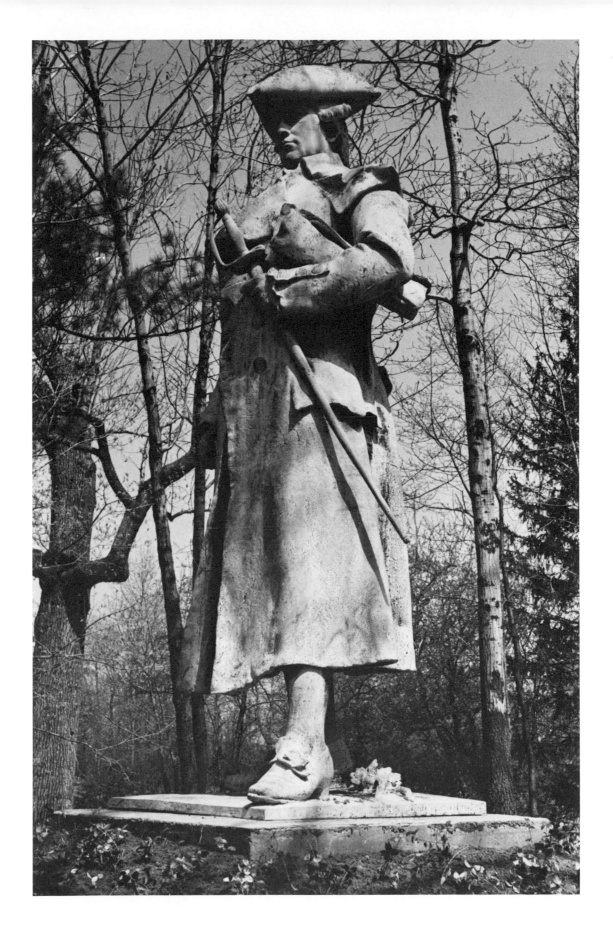

WILLIAM PRESCOTT

Bunker Hill

The Bunker Hill Monument Association dedicated in 1881 at the foot of their granite shaft a bronze statue of Colonel William Prescott (1726–1795), who was in command of the fortification of Breed's Hill before the battle. William Wetmore Story, who modelled the statue, basing it upon the appearance of Arthur Dexter, a great-grandson of the subject living in Rome at the time, did considerably better than he had with Edward Everett. The day of the battle being warm, Prescott had discarded his uniform, and fought informally in the broad-brimmed hat and banyan coat depicted by Story. As Prescott's grandson, William Hickling Prescott, married the granddaughter of Captain John Linzee, who commanded the British sloop of war *Falcon,* the crossed swords of American and British commanders in this battle long hung in the historian's library at 55 Beacon Street. They are now in the possession of the Massachusetts Historical Society.

94

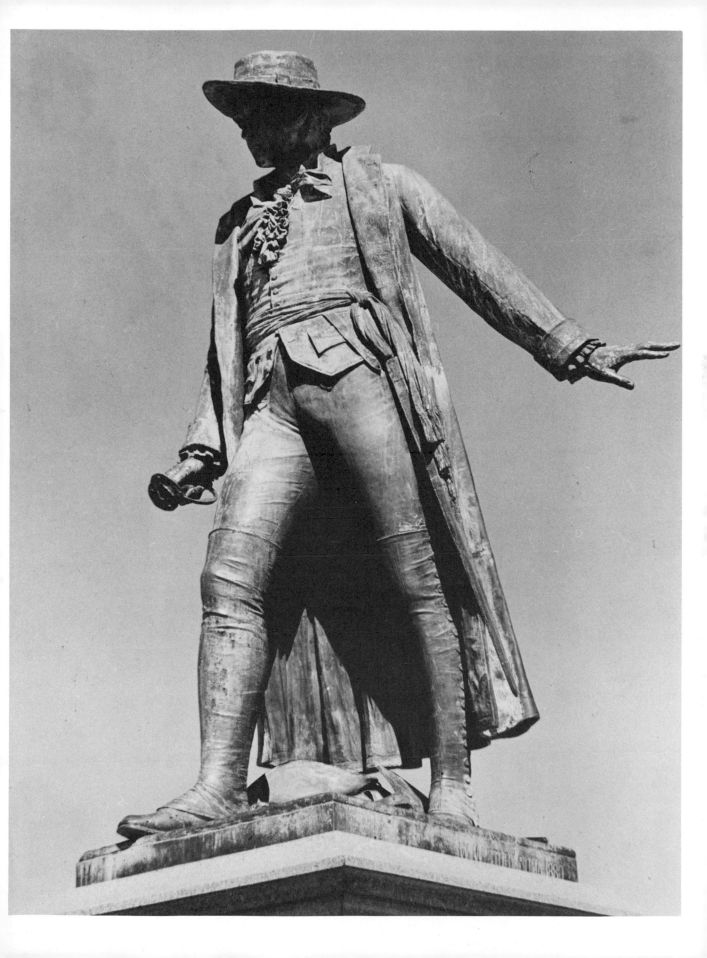

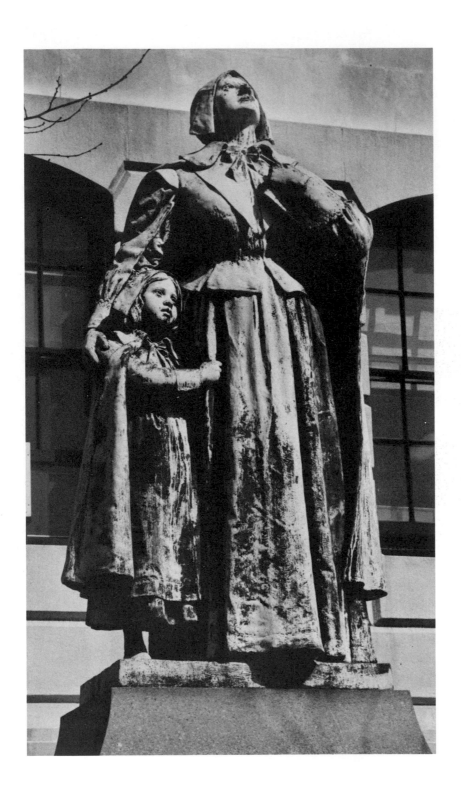

ANNE HUTCHINSON

State House

In front of the west and east wings of the State House are twentieth century memorials to seventeenth century strong-minded ladies who grievously disturbed the peace of Boston in their time. Anne Hutchinson (1591–1643), who arrived in Boston in 1634, so vigorously expounded a "covenant of grace" that she was within three years tried for "traducing the ministers and their ministry" and banished from the church and colony. In 1638 she emigrated to Rhode Island, and in 1642 to Pelham Bay in the Bronx, where she was killed by Indians. Cyrus E. Dallin (1861–1944) represented her standing, with her small daughter by her side, her left arm clasping a Bible to her breast, and her face uplifted. His bronze statue, given to the Commonwealth in 1922 by the Anne Hutchinson Memorial Association and the State Federation of Women's Clubs, was placed outside the west wing that was added to the State House in 1914–17.

97

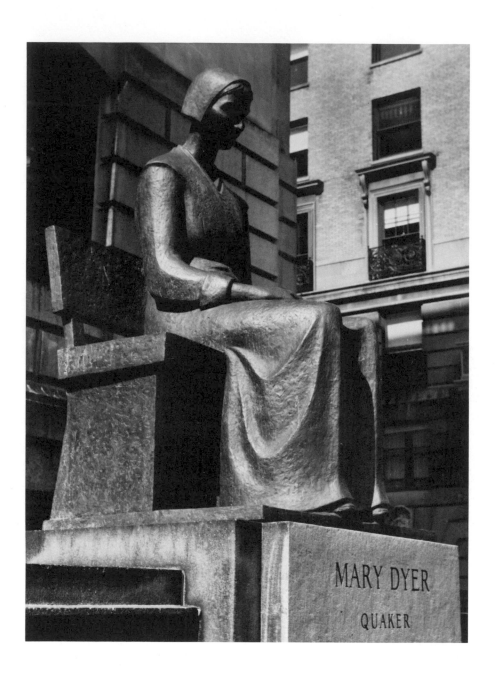

MARY DYER

State House

In front of the east wing of the State House is a seated bronze statue of the Quaker, Mary Dyer, by Sylvia Shaw Judson, erected by the Commonwealth in 1959 with a legacy from Zenas Ellis of Fair Haven, Vermont. It is a charming idealization, considerably more peaceful than its subject was in life. Friendly and sympathetic with Anne Hutchinson during the Antinomian controversy, Mary Dyer and her husband withdrew to Rhode Island in 1638. Having become a Quaker, Mary was arrested when she passed through Boston in 1657. Released, she returned to Rhode Island, but in 1659 was back in Boston to visit other imprisoned Quakers. Banished on 12 September 1659, and having returned the next month, she was sentenced to be hanged. Reprieved at the last moment and sent back to Rhode Island, she obstinately returned to Boston, where she clearly was not wanted, and *was* hanged on 1 June 1660.

PAUL REVERE

Paul Revere Mall

Paul Revere (1735–1818), Boston craftsman, is best represented in John Singleton Copley's portrait of 1768–1770, which shows him at his silversmith's bench, working on a teapot. Primarily a silversmith, he also cast bells, made cannon, ran a copper foundry, and indulged in Revolutionary politics. But because Longfellow described in verse his ride to Lexington on the night of 18 April 1775, most Americans visualize Revere as a romantic figure on a horse, like the equestrian statue by Cyrus E. Dallin. Although modelled in 1885, it was fifty-five years in finding a taker. Finally it was cast for the city of Boston, at the expense of the George Robert White Fund, installed in the Paul Revere Mall that connects Hanover Street with Christ Church, Salem Street ("The Old North Church" where the signal lanterns were hung), and dedicated on 22 September 1940.

100

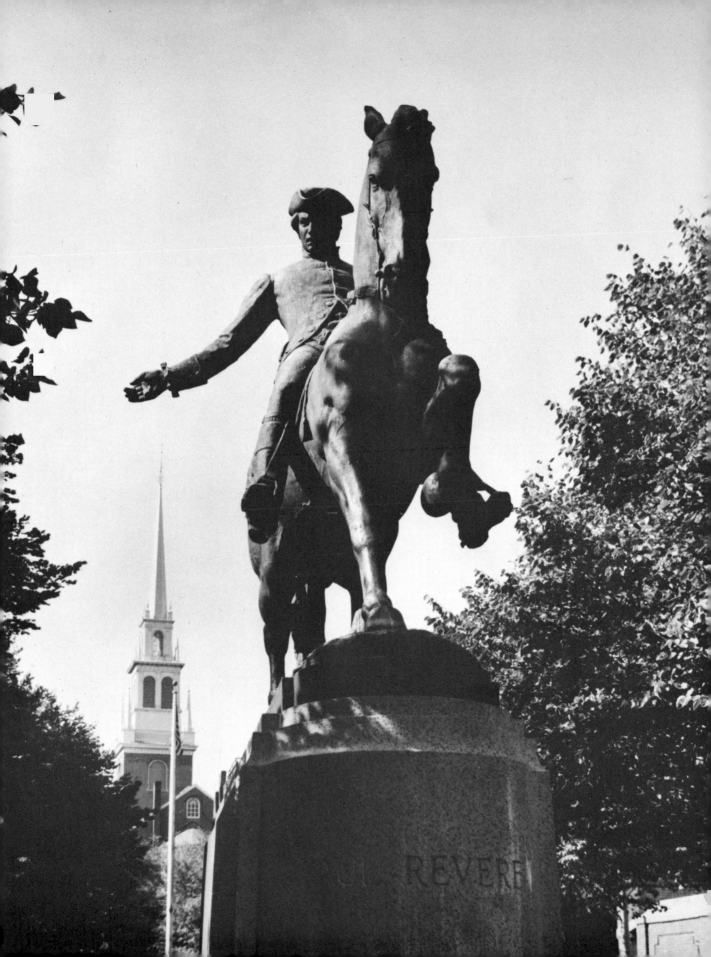

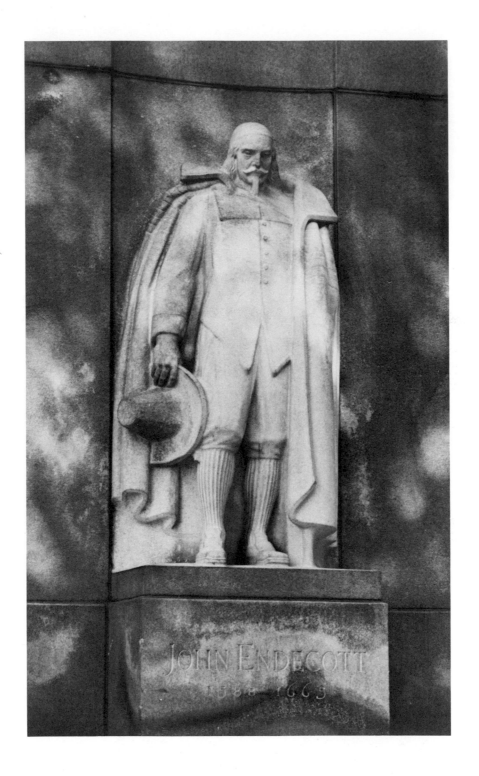

JOHN ENDECOTT
1588 - 1665

JOHN ENDECOTT

Forsythe Way

I<small>N</small> only one instance has a Boston family spent its own money to place an ancestor on a pedestal beside a public highway. This occurred in 1937 when a rather formidable stone statue of Governor John Endecott (1589–1665) by C. P. Jennewein was installed in Forsythe Way, near the Museum of Fine Arts. Funds for this memorial were bequeathed by the subject's descendant, George Augustus Peabody (1831–1929). The project was carried out by Peabody's nephew, William Crowninshield Endicott (1860–1936), who himself spared no pains to honor his stern and irascible Puritan ancestor. He had a medal by Laura Gardin Fraser struck in gold and bronze to commemorate Governor Endecott during the Massachusetts Bay Tercentenary of 1930 and persuaded Lawrence Shaw Mayo to write a biography of him, published in 1936.

HENRY CABOT LODGE

State House

Beyond the west wing of the State House stands a bronze statue of Henry Cabot Lodge (1850–1924), a Republican member of the House of Representatives from 1886 until 1893, and United States Senator from 1893 until his death over thirty years later. Although remembered chiefly as the implacable foe of Woodrow Wilson and the League of Nations, Lodge after being graduated from Harvard College and the Law School received in 1876 the first Ph.D. in political science awarded by the university, helped edit the *North American Review*, and wrote four historical biographies. His statue by Raymond A. Porter was commissioned by the Commonwealth to commemorate his services in Congress. At the dedication on 26 October 1932, David I. Walsh, Lodge's sometime colleague and successor in the Senate, delivered the oration. A walk from Beacon Street leads in to the Lodge statue.

104

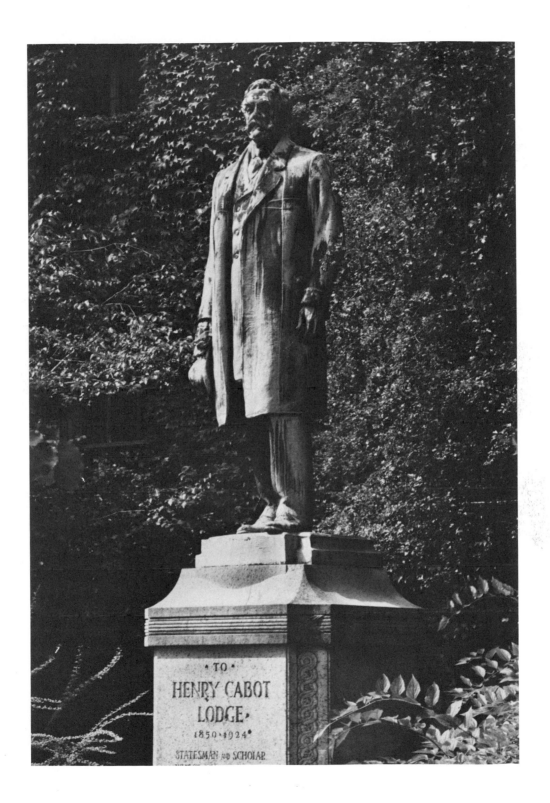

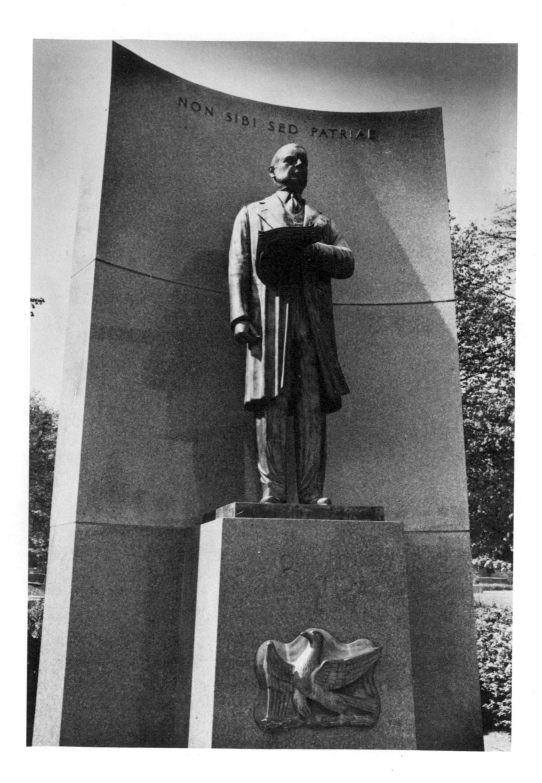

DAVID IGNATIUS WALSH

Charles River Esplanade

DAVID IGNATIUS WALSH (1872–1947), a lawyer who entered Democratic politics in his twenties, was Lieutenant Governor of Massachusetts, 1913–14, Governor in 1914–16, and was elected United States Senator in 1919. Although defeated for re-election at the end of his first term, he returned to the Senate in 1926 and remained there for more than twenty years. When the Metropolitan District Commission held an open competition for a statue of Senator Walsh, the commission was awarded in 1954 to the Boston sculptor Joseph A. Coletti (born 1898). The monument, which stands on the Esplanade by the Charles River, at the foot of Beacon Hill, depicts in bronze the Senator standing against a curving wall, recalling the shape of the nearby music shell. On the wall above the statue is inscribed: NON SIBI SED PATRIAE.

EDWARD LAWRENCE LOGAN

Logan International Airport

At the entrance to the Logan International Airport in East Boston stands a bronze statue of the lawyer, judge, and soldier, Lieutenant General Edward Lawrence Logan (1875–1939) in whose honor this busy terminal was named. Born in South Boston, Logan was graduated from Harvard College in 1898 and the Harvard Law School in 1901. He served in the Boston City Council and in both houses of the Massachusetts Legislature before his appointment to the bench of the Municipal Court of the South Boston District. He served in the Spanish-American War in 1898, on the Mexican Border in 1916, and during World War I as colonel of the 101st Infantry; thereafter he attained high rank in the Massachusetts National Guard. The statue by Joseph A. Coletti was unveiled in a public ceremony on 20 May 1956.

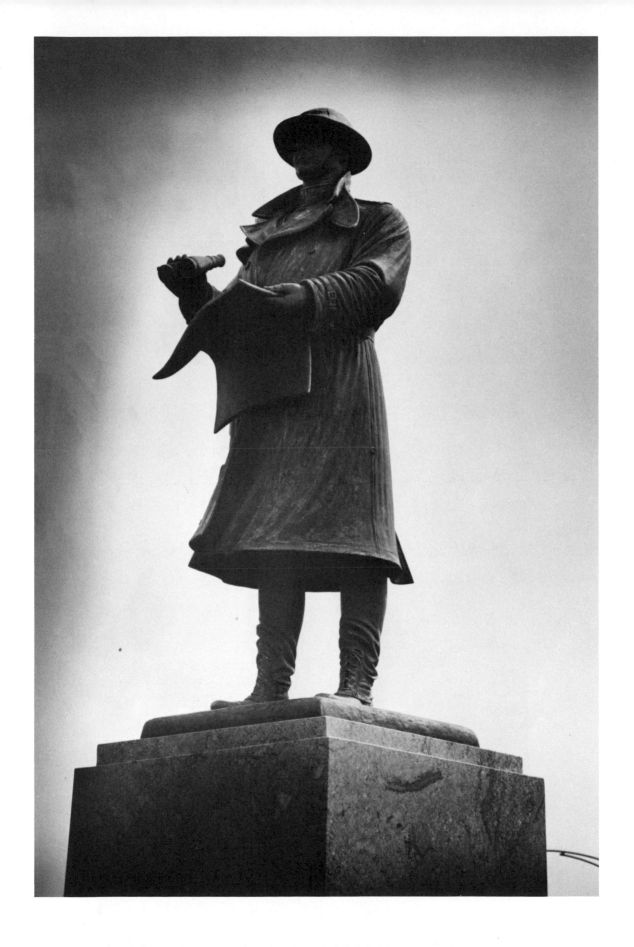

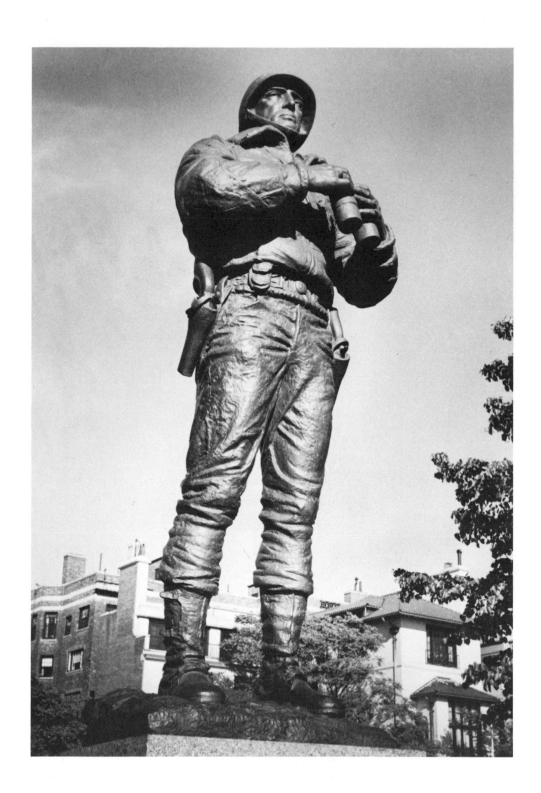

GEORGE SMITH PATTON, JR.

Charles River Esplanade

O<small>N</small> the Esplanade near the statues of Senator Walsh and the transplanted Civil War general, Charles Devens, stands the bronze statue of a more recent and infinitely more vivid figure, the dashing and profane General George Smith Patton, Jr. (1885–1945), the most dramatic officer of his rank in World War II. It is the work of James Earle Fraser (1876–1953), a pupil of Augustus Saint-Gaudens, whose buffalo nickel is familiar to every American. Fraser, who also modelled the "End of the Trail" for the Panama-Pacific Exposition, as well as sculptures for the Supreme Court and the National Archives buildings in Washington, did the statue of General Patton for the U.S. Military Academy at West Point. The Boston statue is a replica, commissioned by the Commonwealth of Massachusetts, and erected in the mid-fifties, a decade after the general's death.

MAURICE J. TOBIN

Charles River Esplanade

Keeping eternal company with Devens, Walsh, and Patton near the music shell on the Esplanade is a twentieth century Boston Democratic politician, Maurice J. Tobin (1901–1953). His service as Mayor of Boston from 1938 to 1944 was a refreshing interlude between the penultimate and ultimate flowerings in City Hall of that hardy perennial, James Michael Curley. Tobin went on to be Governor of Massachusetts in 1946–47, while in 1948 he was appointed Secretary of Labor in President Truman's cabinet. Within the decade of his untimely death, the Commonwealth commissioned this bronze statue of him by Emilius R. Ciampa, a Boston sculptor who was then manager of the Caproni Galleries, Inc. More recently the Legislature has renamed the Mystic River Bridge in Tobin's honor, but many Bostonians still call it by the geographical name that indicates its precise location.

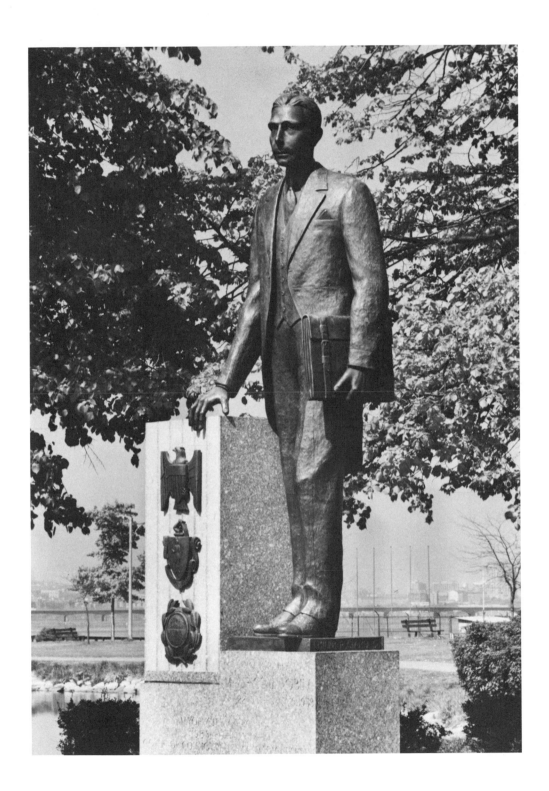

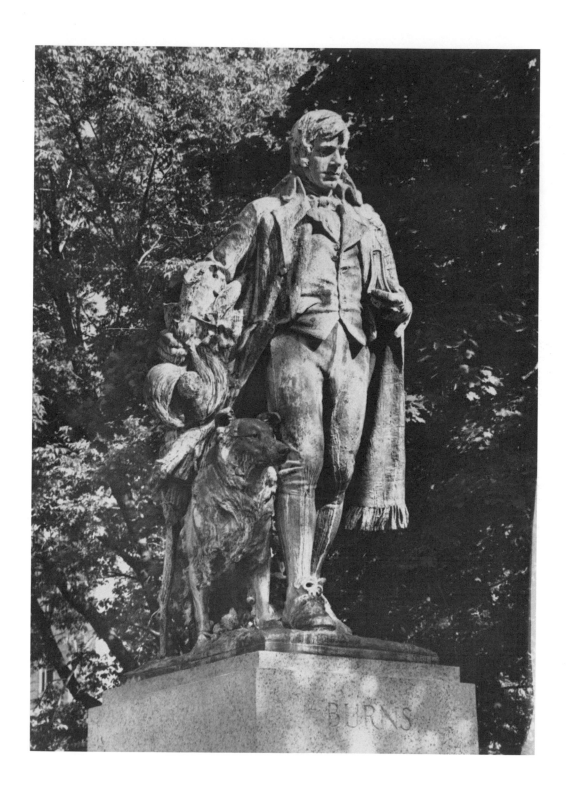

ROBERT BURNS

Homesick Scots, when they reach a certain state of solvency, can never resist putting up a statue of Robert Burns. A charming bronze figure by Henry Hudson Kitson of the poet, book in hand, accompanied by a collie dog, was presented to the city of Boston by the Burns Memorial Association. After four previous attempts to find a suitable location, it was in 1920 installed in a thicket near the Muddy River, behind the fire alarm station at the Westland Avenue entrance to the Fenway. Every so often zealous Scots burst into print or harass city officials to have Bobbie moved from his bulrushes in the Fenway to a more central and visible position in the city. There are those, however, who think Burns would find his present secluded habitat more congenial than one open to the gaze of passing Puritans.

TADEUSZ ANDRZEJ BONAWENTURA KOSCIUSZKO

Public Garden

In the last years of the nineteenth century, when descendants of "old immigrants" began banding together in hereditary organizations which appeared to claim a monopoly on the creation of the Republic, it is small wonder that some of the newer groups began to assert that a couple of Irishmen, Frenchmen, Germans, or Poles had won the American Revolution. So although the American Revolutionary service of Tadeusz Andrzej Bonawentura Kosciuszko (1746–1817) began in the summer of 1776 after military operations had moved south of Massachusetts, Boston has an attractive bronze statue of this Polish patriot. The work of Mrs. Henry Hudson Kitson, it was placed on the Boylston Street Mall of the Public Garden in 1927 as a companion to Charles Sumner, Wendell Phillips, and Colonel Thomas Cass.

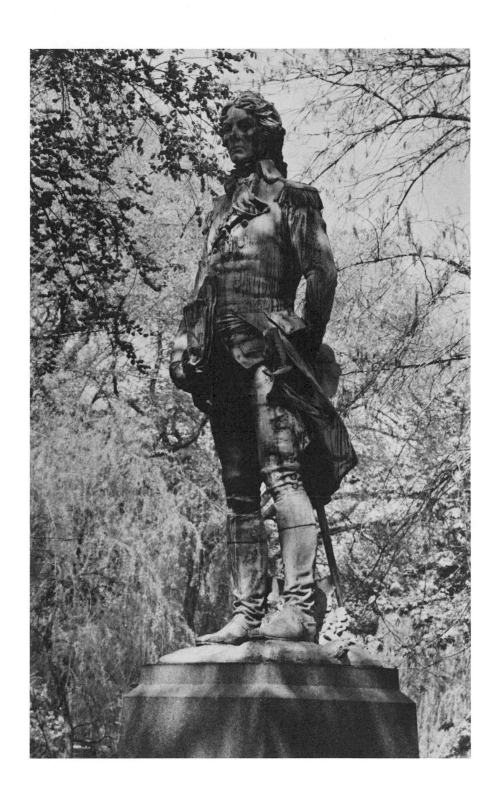

INDEX OF SUBJECTS

INDEX OF SCULPTORS